P9-EGK-882

ALSO BY FREDERICK FRANCK

Days with Albert Schweitzer (1959)

My Friend in Africa (1960)

African Sketchbook (1961)

My Eye Is in Love (1963)

Outsider in the Vatican (1965)

I Love Life (19 67)

Exploding Church (1968)

Simenon's Paris (1969)

The Awakened Eye (1979)

READERS:

Au Pays du Soleil (1958)

Au Fil de l'Eau (1964)

Croquis Parisiens (1969)

Tutte le Strade portano a Roma (1970)

THE ZEN of SEEING

Vintage Books A Division of Random House, New York

THE ZEN of SEEING

SEEING/DRAWING as meditation

Drawn and handwritten by

FREDERICK FRANCK

VINTAGE BOOKS EDITION

COPYRIGHT © 1973 by Frederick Franck.

All rights reserved under International and Pan-American
Copyright Conventions. Published in the United States by
Random House, Inc., New York, and simultaneously in
Canada by Random House of Canada Limited, Toronto.
Originally published by Alfred A. Knopf, Inc.

Manufactured in the United States of America.

Quotations of Chinese and Japanese sayings and poems are
often paraphrased, according to the author's understanding of
them, from the works of D. T. Suzuki and R. H. Blythe.

Title calligraphy by Carole Lowenstein
Cover design by Clint Anglin

To all who were
my teachers
and still are...

FOREWORD

This book is handwritten because, in its way, it is a love letter, and love letters should not be typeset by compositors or computers. It may be a little slower to read, but there is no hurry, for what I want to share with you took a long time to experience.

I write in the first-person singular, but when I speak of "I," I really mean "You."

"Deeply thinking of it,
I and other people,
There is no difference
As there is no mind
Beyond the Mind."

 Ikkyu (fifteenth century)

INTRODUCTION:

AN EXPERIMENT IN SEEING THAT BECAME "AN UNFORGETTABLE EXPERIENCE"

The letter invited me to give what it called "a workshop." The subject: "Creativity in a Non-Creative Environment," whatever that meant. I accepted for mixed and not all too noble reasons. But then the time drew near and escape was no longer possible. I became nervous. I had never attended such a weekend gathering on campus, let alone "given" one.

What was I going to do? Sixty-odd people between eighteen and sixty-four had registered and paid for the workshop. How was I going to keep them busy, or even awake, for those two and a half days? I feverishly prepared lectures and a pack of slides on art as material for "questions" and "discussions." I would start with an introductory talk on the relationship between drawing, painting, and sculpture. But it all turned out differently...

In that first lecture I asked the rhetorical question WHO IS MAN, THE ARTIST? and answered it by saying: HE IS THE UNSPOILED CORE OF EVERYMAN, BEFORE HE IS CHOKED BY SCHOOLING, TRAINING, CONDITIONING UNTIL THE ARTIST-WITHIN SHRIVELS UP AND IS FORGOTTEN. Even in the artist who is professionally trained to be consciously "creative" this unspoiled core shrivels up in the rush toward a "personal style," in the heat of competition to be "in."

And yet, I added, that core is never killed completely. At times it responds to Nature, to beauty, to Life, suddenly aware again of being in the presence of a Mystery

that baffles understanding and which only has to be glimpsed to renew our spirit and to make us feel that life is a supreme gift. Many years of pre-occupation with Zen have kept me awake to the experience of this opening up of life.

Suddenly I noticed that the strangers' faces in front of me began to look less strange. I was making contact, and encouraged by this rapport, I forgot my carefully hatched lecture and started to talk freely about seeing, about drawing as "The Way of Seeing," about something I called SEEING/DRAWING (I coined that on the spot), and about this SEEING/DRAWING as a way of meditation, a way of getting into intimate touch with the visible world around us, and through it... with ourselves.

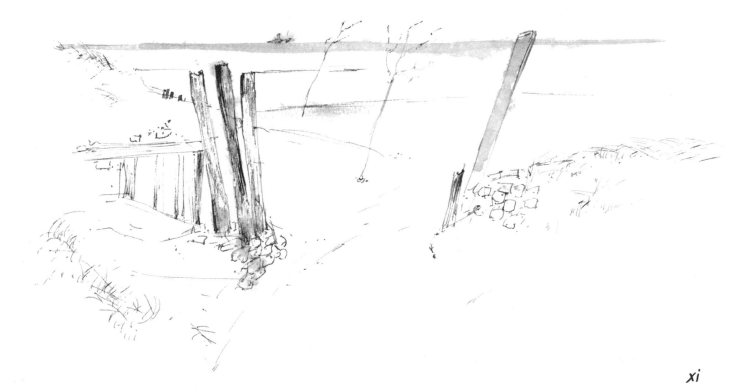

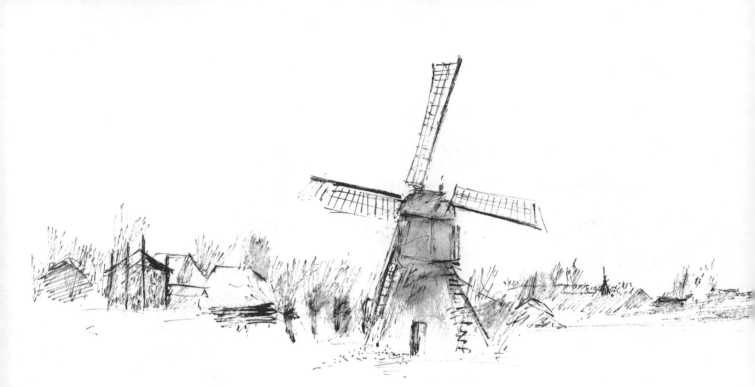

A "non-creative environment" is one that constantly bombards
us, I said, overloads our switchboard with noise, with
agitation and visual stimuli. Once we can detach our-
selves from all these distractions, find a way of "inscape,"
of "centering," the same environment becomes "creative"
again. SEEING/DRAWING is such a way of inscape from
the overloaded switchboard. It establishes an island of
silence, an oasis of undivided attention, an environment
to recover in . . .

During the question period that followed I found out that
 although there were in my workshop a textile designer,
 a few teachers, and various people who confessed to
 "dabbling" in painting, there were no professional artists.
 One of the teachers said: "I'd love to try your
 SEEING/DRAWING, but how on earth do I start? I can't
 even draw a straight line!"
"I'll show you tomorrow morning," I promised, for she had
 given me the idea — the idea that was to become this book.

The next morning - it was a sunny springday — I distributed cheap sketchpads and pencils and transferred my workshop to the grounds of the college. I asked the participants to sit down somewhere on the lawn." Anywhere, as long as you leave at least six feet of space between one another. Don't talk, just sit and relax.

"Now, let your eyes fall on whatever happens to be in front of you. It may be a plant or a bush or a tree, or perhaps just some grass. Close your eyes for the next five minutes...

"Now, open your eyes and focus on whatever you observed before — that plant or leaf or dandelion. Look it in the eye, until you feel it looking back at you. Feel that you are alone with it on Earth ! That it is the most important thing in the universe, that it contains all the riddles of life and death. It does !

You are no longer looking, you are SEEING...

"Now, take your pencil loosely in your hand, and while you keep your eyes focused allow the pencil to follow on the paper what the eye perceives. Feel as if with the point of your pencil you are caressing the contours, the whole

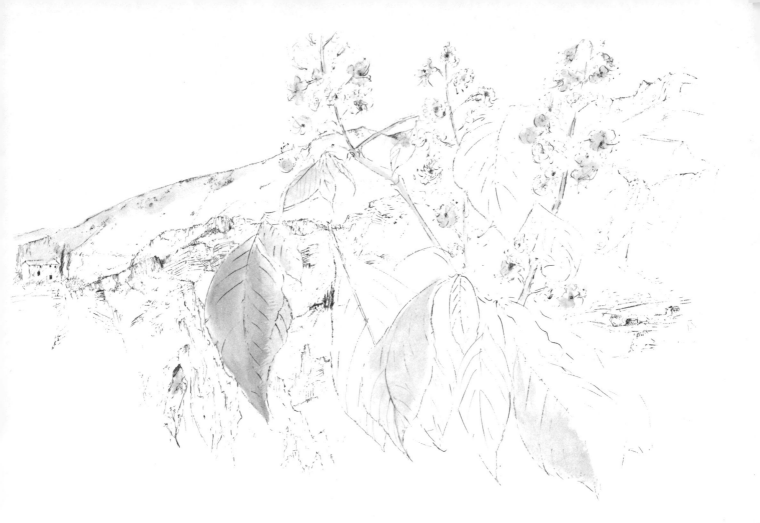

circumference of that leaf, that sprig of grass. Just let your hand move! Don't check what gets onto the paper, it does not matter at all! If your pencil runs off the paper, that's fine too! You can always start again. Only, don't let your eye wander from what it is seeing, and don't lift your pencil from your paper! And above all: don't try too hard, don't "think" about what you are drawing, just let the hand follow what the eye sees. Let it caress . . . "

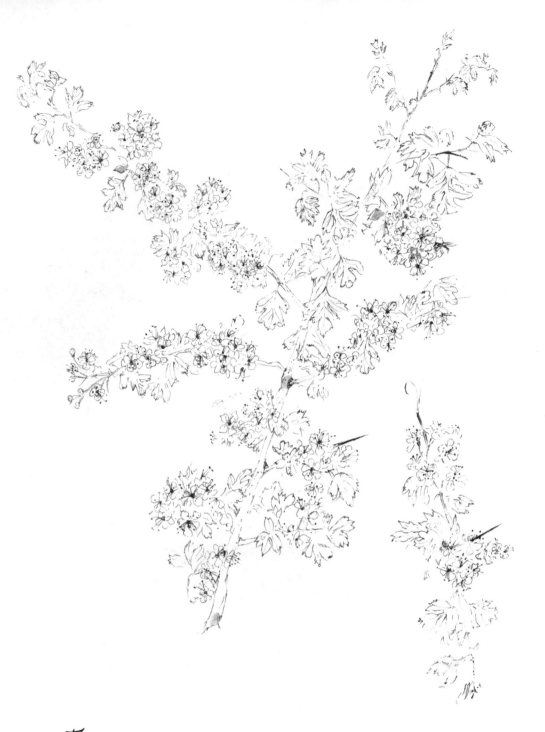

They sat and saw and drew for hours, until lunchtime, like
good children. I walked around a few times, pointed at
a curling, an unfurling, a drooping, a shriveling, a
branching, a striving, a groping . . .

A pretentious one in owl glasses was doing a spiky
 abstraction. I tried to talk her into using her eyes. "Please
 realize you are not 'making a picture,' you are not
 being 'creative.' We are just conducting an experiment
 in SEEING, in undivided attention! The experiment is
 successful if you succeed in feeling you have become that
 leaf or that daisy, regardless of what appears on the
 paper."
Then for a while I forgot about them,
 for I discovered a marvelously
 hairy caterpillar on a leaf.
 I could not resist it...
At lunch my workshop
 decided unanimously
 to continue until dinnertime.
"Wonderful! And then let's have
 an exhibition tonight! But one
that is strictly anonymous. Don't sign your drawings. You'll
recognize your own and that is all that is necessary.
No prizes, no honorable mentions! Arrange your drawings
on the tables of the cafeteria or pin them on the walls.

I'll go around and tell you what I see in them, then we'll have a general discussion about the experiment."

A young woman asked: "Why am I so scared?"

"Maybe you are afraid you are making a fool of yourself and that all the others are so much better! Or maybe it frightens you to be all on your own, without radio or TV, without talking. Alone in the world with your clump of grass, alone with your eyes..."

The drawings were a revelation, as were the comments of the people who had made them. There was a drawing of a willow that was as awkward as it was lovely. The willow danced like a prima ballerina, or better, it danced as only willows dance. The woman who drew it was white-haired and in her sixties.

"I don't even know how I did it," she said. "I did what you suggested and then it just happened! I had never drawn since I quit school."

The one who "couldn't draw a straight line" had traced a complex patch of ivy in a spidery handwriting of exquisite sensitivity.

The abstract lady had persisted in her spiky triangles, but another said: "I have grown geraniums for thirty years, but, believe it or not, I never knew what a geranium looked

like, how it was made, until I drew one today." (Her drawing had very little resemblance to any geranium, past or present, but then we were not out to make "art" but to experiment with seeing.)

Someone else said: "I am a widow and live alone, and I often feel lonely. Today I learned that if you really see the things around you, you're not lonely any more! I may never be any good at it, but I'll go on drawing!"

And another: "I have painted for years. I have been in local exhibitions, but today's experience makes me wonder whether I have been deceiving myself, whether I really ever saw, if I really used my eyes. Anyway, it was an unforgettable experience!"

They all agreed: "A wonderful experience!"

IN THIS TWENTIETH CENTURY, TO STOP RUSHING
AROUND, TO SIT QUIETLY ON THE GRASS, TO SWITCH
OFF THE WORLD AND COME BACK TO THE EARTH, TO
ALLOW THE EYE TO SEE A WILLOW, A BUSH, A
CLOUD, A LEAF, IS "AN UNFORGETTABLE EXPERIENCE"...

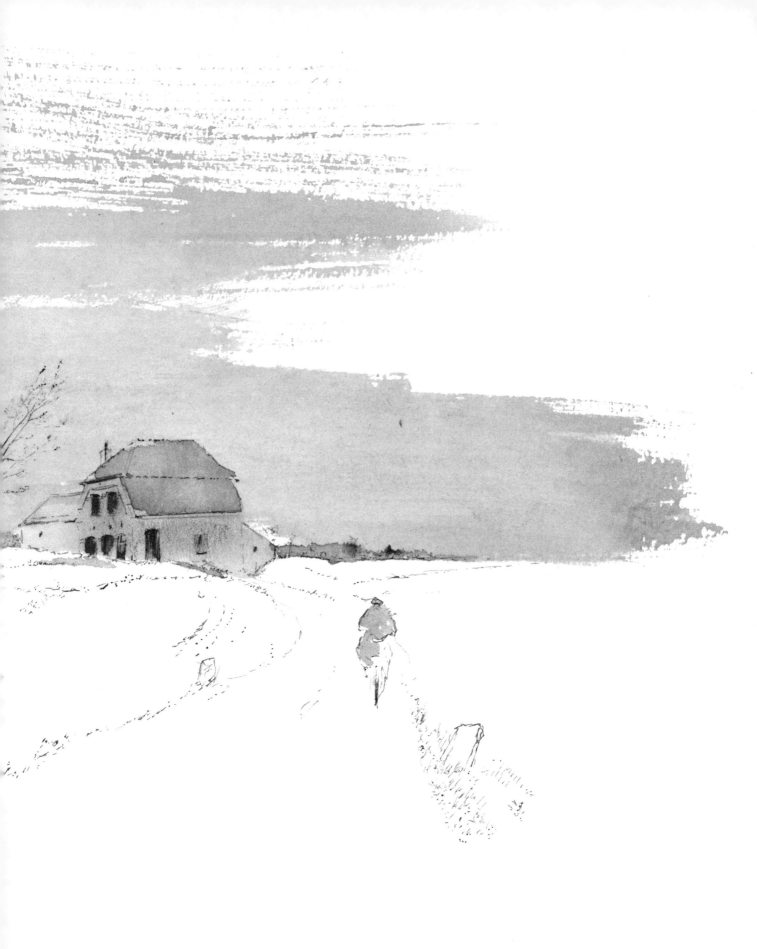

THE ZEN of SEEING

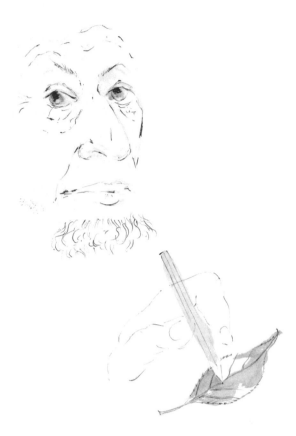

We do a lot of looking: we look through lenses, tele-
scopes, television tubes... Our looking is perfected every
day _ but we see less and less.
Never has it been more urgent to speak of SEEING.
 Ever more gadgets, from cameras to computers, from
art books to videotapes, conspire to take over our
thinking, our feeling, our experiencing, our seeing.
Onlookers we are, spectators... "Subjects" we are,

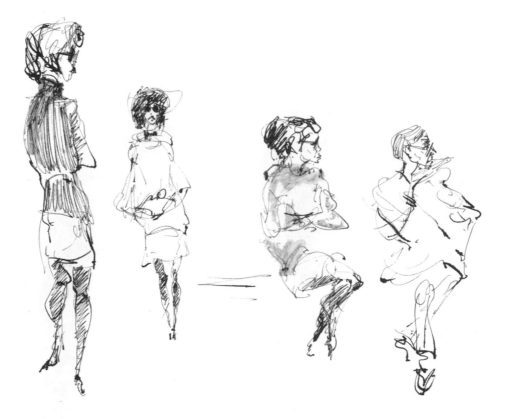

that look at "objects". Quickly we stick
labels on all that is, labels that stick once
and for all. By these labels we recognize every—
thing but no longer SEE anything. We know the
labels on all the bottles, but never taste the wine.
Millions of people, unseeing, joyless, bluster through life in
their half sleep, hitting, kicking, and killing what they
have barely perceived. They have never learned to SEE,
or they have forgotten that man has eyes to SEE, to
experience.

WHEN A MAN NO LONGER EXPERIENCES, THE ORGANS
OF HIS INNER LIFE WITHER AWAY. ALONE OR IN
HERDS HE GOES ON BINGES OF VIOLENCE AND DESTRUCTION.

Looking and seeing both start with sense perception, but there the similarity ends. When I "look" at the world and label its phenomena, I make immediate choices, instant appraisals — I like or I dislike, I accept or reject, what I look at, according to its usefulness to the "Me"... THIS ME THAT I IMAGINE MYSELF TO BE, and that I try to impose on others.

The purpose of "looking" is to survive, to cope, to manipulate, to discern what is useful, agreeable, or threatening to the Me, what enhances or what diminishes the Me. This we are trained to do from our first day.

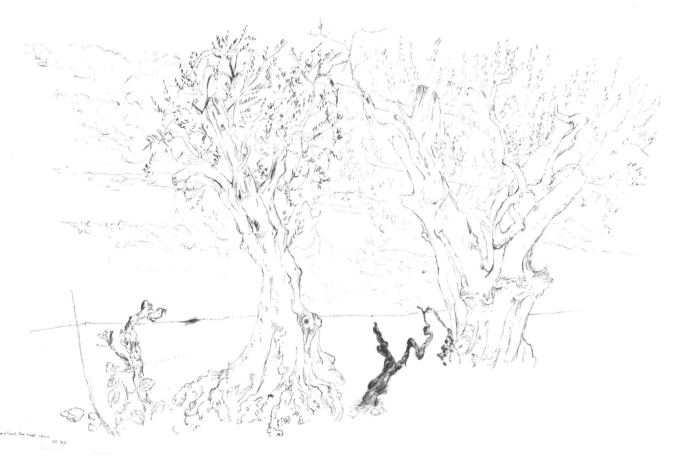

When, on the other hand, I SEE – suddenly I am all eyes, I forget this Me, am liberated from it and dive into the reality of what confronts me, become part of it, participate in it. I no longer label, no longer choose. ("Choosing is the sickness of the mind," says a sixth-century Chinese sage.)

It is in order to really SEE, to SEE ever deeper, ever more intensely, hence to be fully aware and alive, that I draw what the Chinese call "The Ten Thousand Things" around me. Drawing is the discipline by which I constantly rediscover the world.

I have learned that what I have not drawn I have never really seen, and that when I start drawing an ordinary thing I realize how extraordinary it is, sheer miracle: the branching of a tree, the structure of a dandelion's seed puff. "A mouse is miracle enough to stagger sextillions of infidels," says Walt Whitman. I discover that among The Ten Thousand Things there is no ordinary thing. All that is, is worthy of being seen, of being drawn.

Seeing and drawing can
 become one, can become
 SEEING/DRAWING. When
 that happens there is no more
 room for the labelings, the choices of the Me. Every in-
 significant thing appears as if seen in its three dimensions,
 in its own space and in its own time. Each leaf
 of grass is seen to grow from its own roots, each
 creature is realized to be unique, existing now/here on
 its voyage from birth to death. No longer do I "look"
 at a leaf, but enter into direct contact with its life-
 process, with Life itself, with what I, too, really am. I
 "behold the lilies of the field" . . . and "see how they
 grow"! Their growing is my growing, their fading I share.
 Becoming one with the lilies in SEEING/DRAWING, I become
 not less, but more myself. For the time being the split
 between Me and not-Me is healed, suspended.

7

What really happens when seeing and drawing become SEEING/ DRAWING is that awareness and attention become constant and undivided, become contemplation. SEEING/DRAWING is not a self-indulgence, a "pleasant hobby", but a discipline of awareness, of UNWAVERING ATTENTION to a world which is fully alive. It is not the pursuit of happiness, but stopping the pursuit and experiencing the awareness, the happiness, of being ALL THERE. It is a discipline that costs nothing, that needs no gadgets. All I carry is a pen in my pocket, a sketchbook under my arm. This eye is my lens. This eye is the lens of the heart, open to the world. My hand follows its seeing.

FOR THE ARTIST-WITHIN (who must exist in everyone, for if man is created in God's image, it can only mean that he is created creative) THERE IS NO SPLIT BETWEEN HIS SEEING, ART AND "RELIGION" IN THE SENSE OF REALIZING HIS PLACE IN THE FABRIC OF ALL THAT IS. And since this book is a book on SEEING, and on the heightened awareness of SEEING/DRAWING, I must speak of Zen. There is no split between a man's being, his art and what one might call his "religion," unless there is a

split in the man. These three are inextricably inter-woven: they are one.

What is referred to in this book as Zen is definitely not something exotically Oriental, certainly not a fad, and not even a Buddhist sect. The thirteenth-century Zen sage Dōgen warns: "Whosoever speaks of Zen as if it were a Buddhist sect or school of thought is a devil."

What then is Zen?

Zen is: being in touch with the inner workings of life.

Zen is: life that knows it is living.

Zen is: this moment speaking as time and as eternity.

Zen is: seeing into the nature of things, inside and outside of myself.

Zen is: when all living things of the Earth open their eyes wide and look me in the eye...

This radically realistic and experiential approach to Reality, although not exclusively Oriental, has been repressed in the West. The great mystics, and the authentic artists have been in touch with it, however, for on the summits of awareness East and West have always met.

The ninth-century Irish mystic John Scotus Erigena, for instance, knew that "Every visible and invisible creature is an appearance of God," and in the seventeenth century Angelus Silesius rhymed:

"In good time we shall see
God and his light, you say.
Fool, you shall never see
What you not see today!"

And Meister Eckhart in thirteenth-century Europe said: "The eye with which I see God is the same eye with which God sees me."

Eckhart's eye is the one that in the East is called the
"Buddha Eye," or what the <u>Upanishads</u> speak of: "Verily,
oneself is the Eye, the endless Eye." It is the eye not of
the Me, but of "God born in man's soul," of the True Self.
For the "Me," as subject, takes itself as being absolutely real,
and relegates You, the object, at best to some relative reality,
as a mere accompaniment to its glorious solo. You, as object,
are to be manipulated, courted when needed or desired, then
discarded. "I am, you ain't, they ain't" is the credo of the
Me, as it looks at the world without ever seeing it, without
living in it, standing forever poised against it, fighting it.
Forever doomed to be out of touch with it, as it is out of
touch with what the Self really is.

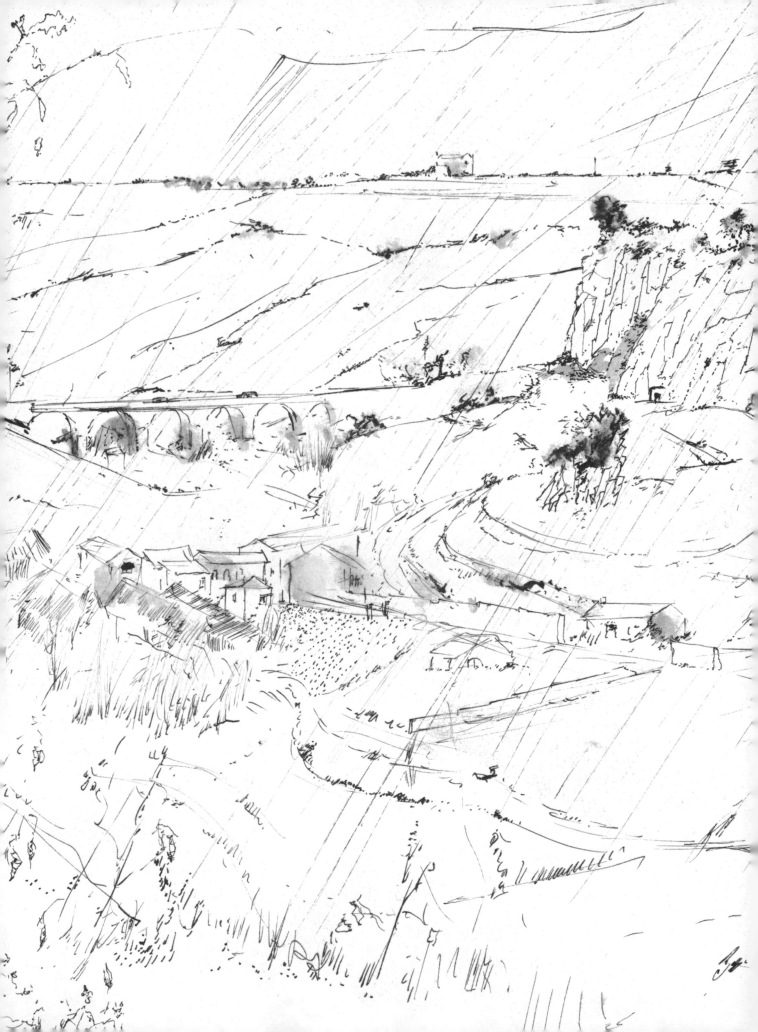

It is no accident that Zen is being discovered in the West at a time of realization that we are fast becoming strangers to our inner life, and that we are all too easily confused about what is real and authentic and what is phoney, about what we truly like and what we think we must like because it happens to be required.

Any work of art motivated or tainted by the slightest consideration of competitiveness, money, sensation, is automatically devoid of Zen, in danger of being close to Kitch. Look at the drawings of the masters: so often they are more direct, more authentic, than their "finished" paintings, closer to Zen. Authentic, personal experience is both aim and method of Zen. The words in which the experience is later expressed are only the byproducts of this absolutely personal, firsthand, inexpressible experience. Yet these words, however inadequate, can help others to sniff the track. On the other hand they may lead others astray, as words are always in danger of doing. "He who knows does not speak, he who speaks does not know," says a Zen aphorism. Another puts it even more radically: "Those who speak cause ignorance and illusion."

What then can one say about the Zen experience, which in
 itself is inexpressible in words?

One can certainly say what it is not. It is _not_ a kind of
 "self-actualization," an expansion of the limited, isolated
 Me, of the empirical ego. It is _not_ an expansion of our
 awareness as separate, isolated egos. Neither is it a
 regression, a return into that vegetative ooze of One-
 ness, before we became aware of our differentiation as
 separate egos. On the contrary, the Zen experience is the
 overcoming of the hallucination that the Me is the valid center of
 observation of the universe. It is a momentary, radical turn-
 about, A DIRECT PERCEPTION OF AND INSIGHT INTO THE
 PRESENCE, INTO THE TRANSIENCY, THE FINITUDE
 THAT I SHARE WITH ALL BEINGS. It is a fleetingness
 that makes this very moment infinitely precious.

The Zen experience is at the same time a direct seeing into
 what I am in reality. It is the healing of the alienation
 (in French "aliéné" means "mad") that hides my true
 identity — which happens on its deepest level to be my identi-
 ty with all that is born and will die. This insight into my real
 condition is the Wisdom that is inseparable from Compassion.

Zazen, or sitting in meditation, is generally considered an
indispensable preparation toward the Zen experience, satori.
But meditation in the sense it is used in this book is far from
a concentrated pondering of a word, a concept, or an idea.
It is a discipline of <u>pointed mindfulness</u> as such, persevered
in to the point where the in-sight breaks through. Zazen
may be the discipline of Zen, but I, for one, am not good
at sitting still for long in the lotus position. I believe that
in SEEING/DRAWING there is a way of awakening the
"Third Eye," of focusing attention until it turns into
contemplation, and from there to the inexpressible fullness,
where the split between the seer and what is seen is obliter-
ated. Eye, heart, hand become one with what is seen
and drawn, things are seen as they are — in their
"isness." Seeing things thus, I KNOW WHO I AM!

SEEING/DRAWING as a technique of contemplation is, I
believe, a way particularly suited to that "Western tempera-
ment" which may be no more than a habitually overstim-
ulated nervous system, an "overloaded switchboard."
It is the discipline through which I extricate myself from
the habitual, the mechanical, the predigested and acquisitive
automatisms of our society. I stand face to face with
a hill, a bird, a human face — with myself, in unwavering
attention.

"If you sit, just sit, don't wobble!" a Zen master warned.
As Westerners, so conditioned to be active, we may perhaps
find it more natural to sit without wobbling if the eye's
attention is focused on a face, a flower, and the hand
may follow it . . .

Hui-neng, the seventh-century Zen patriarch, pointed out that the true relationship between self and other, and which he called "the wisdom of the past, present and future Buddha," is "immanent in our minds," is part of man's spiritual equipment. Some can awaken this wisdom by themselves, he said, others need teachers: "The Truth is understood by the mind (hsin, heart), not by sitting still in meditation."

A Zen monk pointed at a cat and said to his teacher, Joshu (ninth century): "I call this a cat. What do you call it?"

Joshu answered: "You call it a cat."

He might have explained (but Zen masters never "explain"):
"Sticking the label cat on That, you have not said all there is to it by any means..."

Blind to the mystery of the being called "cow," we deal in "cattle," "livestock," "beef-futures." Blind to the mystery of every human being, we manipulate "human material," labor forces, battalions.

There is the story of the Buddha holding up a flower to his disciples and asking them to "say a word about it," something "relevant." The disciples looked, looked intently, then tried to outdo one another in the profundity of their

remarks. Only Mahakasyapa "saw." He remained

silent and smiled an almost imperceptible smile.

To SEE is Mahakasyapa's smile.

But why a flower? Why not a dead rabbit? A minnow? A

poor old soul?

The eye that sees is the I experiencing itself in what it sees. It becomes self-aware, it realizes that it is an integral part of the great continuum of all that is. It sees things such as they are.

No thing is a mere symbol of anything but itself. A rose is not a symbol of love, nor a rock of strength. A rose is a rose experienced in its suchness. To draw it is to say "Yes" to its and my existence.

When all antennae are out, as they are in SEEING/DRAWING, the eye perceives, and a reflex goes from the retina, via what is called "mind" or "heart" to the hand. In SEEING-DRAWING all the hand does is to trace a line, to note it down as an unquestioning instrument. All doubt, all fear, all pretensions have been banished.

Such a drawing is "personal" in the sense one's fingerprint is inevitably personal. It is "original" in the way the ancient Chinese used this word: it is "in harmony with the origins."

How does one make progress in drawing? By making the

eye - heart-hand reflex ever more sensitive, so that the hand may become ever more the willing tool of the eye.

SEEING/DRAWING The Ten Thousand Things is drawing from Nature. But Nature is not all meadows, cows and daisies. It also streets and buildings, coffee cups and airplanes.

A disciple asked: "Is the Nature present everywhere?" He received this answer: "Yes, there is nowhere it is not present!" It is this Nature that Zen points at and aims to confront.

Seeing into one's "own nature," far from being self-analysis as if one were an object — is the perception, the experience, of Nature as it manifests itself in me, outside me. This seeing-into is at the same time the leap out of the isolation of the ME into the community of beings and things, in the absolute present, the Absolute Presence.

↓

You have noticed that until now I have said hardly a word about the how-to of drawing. It is because nearly all hints on this how-to are fraudulent, teach one at best to imitate other people's drawings, to "manufacture" pictures — as if there were not enough mediocre pictures around to last for centuries!

And so I speak, again and again, about experiencing first-hand and about the gift of our eyes to really SEE. "If thine eye is single, the whole body shall be full of light..." So let SEEING/DRAWING be the celebration of experiencing, of the eye in love, instead of the making of pictures to be framed.

In the introduction to this book, I have described an experiment in SEEING, and in letting the hand follow what the eye SEES. By continuing this experiment, the eye is trained to see ever more, ever deeper, the hand follows more obediently, surprising one by registering the lightness of a butterfly, the weight of a rock, the pulsing of a flower, of a face.

There is only one person who can teach you: yourself! There are no shortcuts, no recipes. Any tool will do, any paper.

I happen to draw with a pen, my favorite tool. Maybe you'll like a pencil better, or chalk, or a brush. You will only find out what is best for you by trying all of these. You'll discover a paper that is exactly right for you as you try all kinds of paper, from manila to cheap newsprint to finest Japanese. I buy ordinary 70-lb. offset paper in bulk. It is inexpensive and universally useful. I

don't use ballpoints or felt-tip pens if I can help it, for I find them too insensitive and mechanical. In my hand at least they do not register subtle variations in pressure in response to what my eye perceives. But if I were on an uninhabited island, devoid of animals, trees and plants, I would draw the sand and the rocks all day with a ballpoint and be quite happy. For I would unlearn all I ever thought I knew about rocks and grains of sand: SEEING/DRAWING is the art of un-learning about things.

While drawing a rock I learn nothing "about" rocks, but let this particular rock reveal its rockyness. While drawing grasses I learn nothing "about" grass, but wake up to the wonder of this grass and its growing, to the wonder that there is grass at all.

Everyone thinks he knows what a lettuce looks like. But start to draw one and you realize the anomaly of

having lived with lettuces
all your life but never
having seen one, never having seen
the semi-translucent leaves curling in
their own lettuce way, never having
noticed what makes a lettuce
a lettuce rather than a curly kale.
I am not suggesting that you draw
each nerve, each vein of each leaf,
but that you feel them being there.
What applies to lettuces, applies equally to the all-too-
familiar faces of husbands...wives...

The Zen of SEEING is a way from half-sleep, to full awakening. Suddenly there is the miracle of being really alive with all the senses functioning:

"How wondrously strange and miraculous:
I draw water, I carry fuel."

Hokoji, eighth century

How wondrously strange and miraculous: I SEE!
I see a lettuce! I see you!

The ninth-century Zen master Siubi was asked: "What is the secret of Zen?"

"Come back when there is nobody around and I shall tell you."

The inquirer returned. Siubi took him to a bamboo grove, pointed at the bamboos and said:

"See how long these are. See how short these are!"

Suddenly the questioner SAW, "had a flash of awakening."

What did he see? He had a revelation of sheer existence.

Where there is revelation, explanation becomes superfluous.

Curiosity is dissolved in wonder.

I think of this story whenever I draw grasses and weeds
 along the roadside: "See how long this one, see how bent
 that one, see how straight, how curved, how twisted..."
There are many such stories. A scholar asked Hui-t'ang to
 be initiated in Zen. He felt the master had been holding
 back its central secrets from him.
On a walk in the mountains, while the laurels were in full
 bloom and their fragrance filled the air, Hui-t'ang asked:
 "Do you smell it?"
 the scholar nodded.
"You see!" exclaimed the master,
 "I am hiding nothing
 from you."
The eyes of the scholar were opened.
IF YOU CAN SEE, YOU CAN SEE WITH YOUR NOSE
 AND SMELL WITH YOUR EARS. Gregorian chant
 has the scent of incense. The fragrance of apple blossoms
 can be seen: soft whitish-pink with the golden light
 of spring.

"What is the Buddha-nature?" the ninth-century sage Joshu was asked. He answered: "The cypress tree in the court-yard!" A riddle?

"Split the tree and you will find me, raise the stone and I am there," Jesus said. Without any doubt he had seen the "I am Who I am" revealed in tree and stone, and spoke of this experience.

It is precisely this experience which made Joshu's eye see the Buddha-nature in the cypress tree and which makes us see into the tree's real Being. One might go so far as to say that the tree becomes self-aware in us. The eye accepts it fully and is "delighted in the law of God after the inward man" (Romans VIII:22). For the time being, "thoughts for your life and what ye shall eat...and what ye shall put on" (Matthew V:25) are banished. There is only that tree, being tree.

This apple tree is not the first one I draw, perhaps the thousandth. As my pen follows the trunk, I feel the sap rise through it from roots to spreading branches. I feel in my toes how roots grip earth. In the muscles of my torso I feel the tree's upward groping, its twisting, struggling, its reaching against all resistances, towards the sun. In my arms I sense how the branches must wrest

themselves away from the parental trunk, to find
their own way, fight against the elements.
My fingers become the slender shoots that probe the sky.

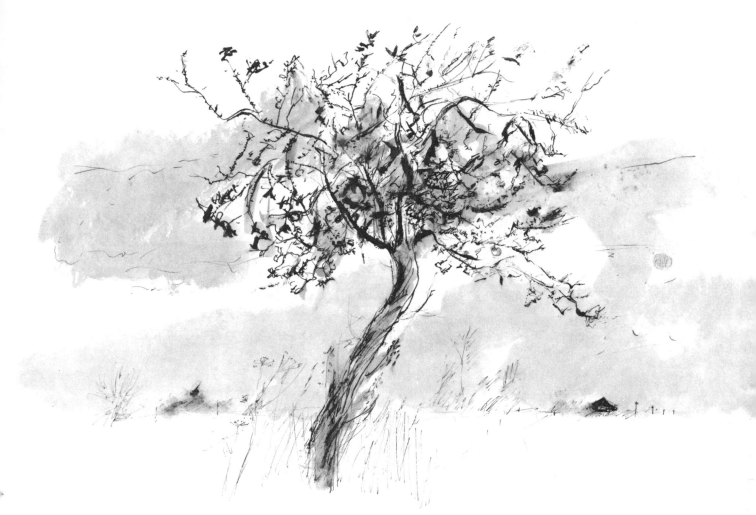

Once, while drawing an apple tree — thinking of nothing,
just watching, seeing, following that life story through
roots, trunk, branches, twigs — the most baffling
riddles solved themselves. THE TREE BECAME MAN-
KIND ROOTED DEEP IN THE EARTH. ITS LIMBS

WERE THE RACES, ITS TWIGS THE FAMILIES. I, WHO ONCE BELIEVED MYSELF TO BE A TREE, SAW MYSELF AS JUST ONE OF THE MYRIAD LEAVES OF ONE LONG SEASON —TO BE BLOWN AWAY A LITTLE EARLIER, A LITTLE LATER. SOME OTHER LEAVES HAD ALREADY FALLEN, MANY REMAINED STUNTED, SOME WERE STILL FRESHLY GREEN IN OCTOBER. BUT SOON THE NOVEMBER STORMS WOULD SWEEP US ALL AWAY. THEN, AFTER THE TORTURES OF FROST, THERE WOULD FOLLOW A NEW EXPLOSION OF PINK BLOSSOMS, THEN LEAVES, AND NEXT AUTUMN THE BRANCHES WOULD ONCE MORE BEND DOWN UNDER BURDENS OF FRUIT. THE TREE HAD BECOME THE TREE OF LIFE.

↓

"The material thing before you, that is It," says Huang-po, the sixth-century Zen master.

When drawing a tree, break off a branch with leaves, blossoms, or fruits. Draw it on the side and become aware of its structure: how the leaves and blossoms are attached. "See how they grow"...

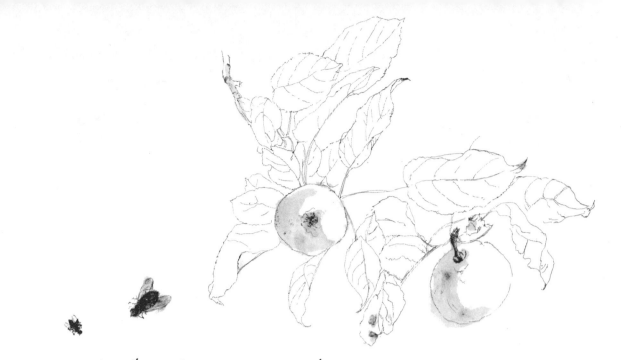

From a mile's distance there is no confusing the characters
of trees — of pines that rise with compulsive straight-
ness into the sky, sprout branches at _precise_ intervals, their
foliage arranged in severe patterns; of feathery poplars,
somber oaks, gay birches that dance, and willows that
bend over backward and forward and send back to earth
long, slender twigs that sweep like girl's hair in the
gentlest breeze.

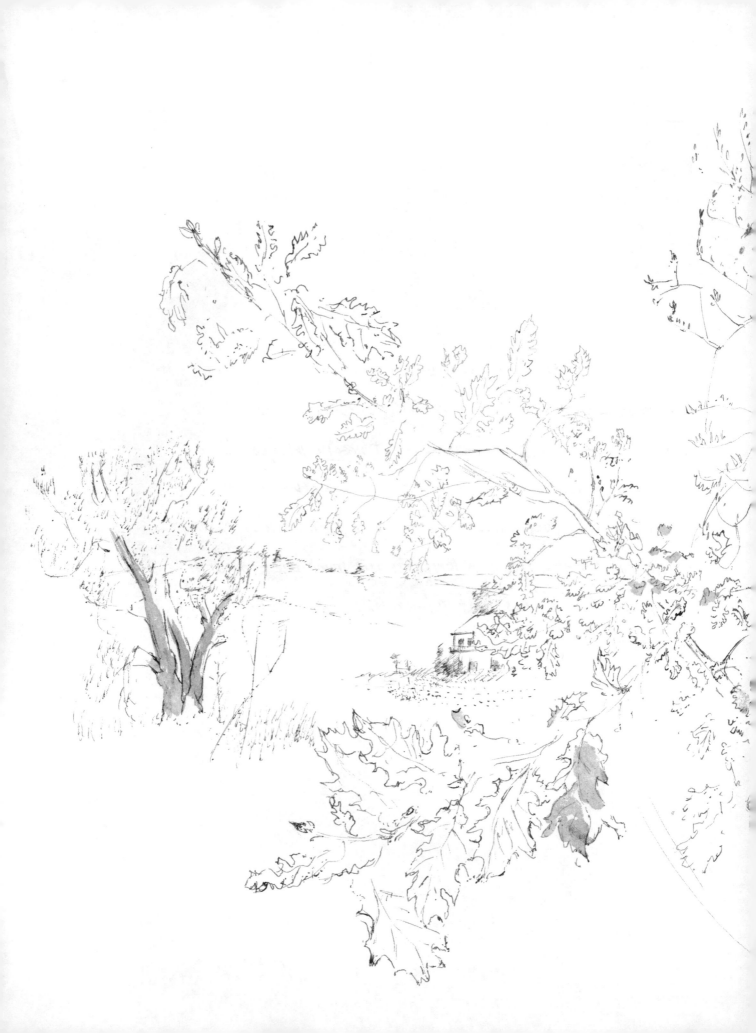

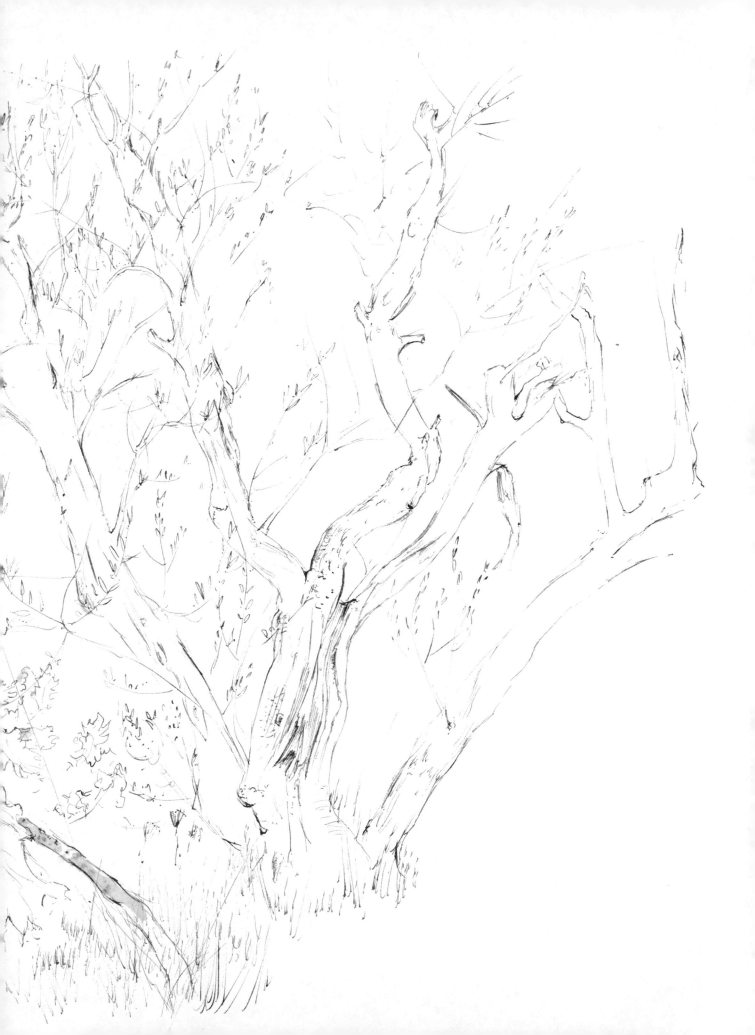

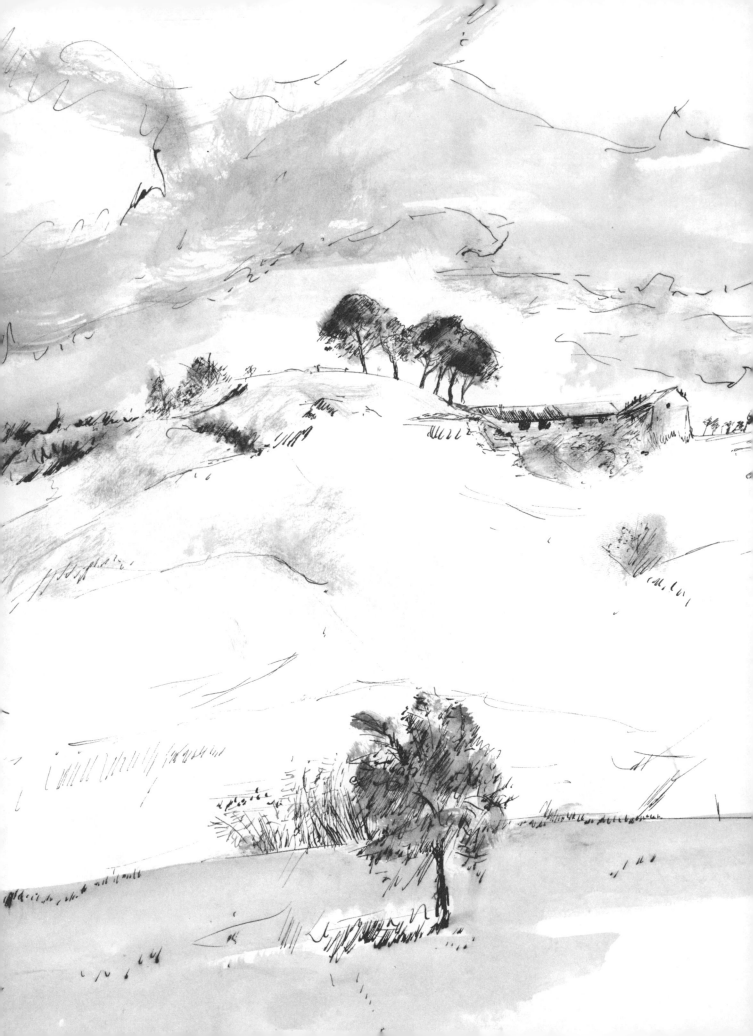

People in the car rave about the landscape: "Oh, how lovely..."
As soon as I sit down in that landscape with my pen,
it is no longer "Oh, how lovely..." It simply _is_, simple
in its intricate complexity.

An ancient Chinese experienced this too:

" I have been gazing
At the scenery of Sho and Shung.
I realize
I am all of a sudden
Part of the landscape."

The pen caresses the round shoulder of a hill, feels its
sensuous, lazy curves, then jumps staccato down the
aggressive juttings of rocky ledges. Trees and plants
push themselves out of the earth, like hairs on the
skin, each one from its own roots. The eye that follows
the sweep of earth intuitively selects hillocks and clumps
of trees that define the space; it picks up and leaves out
forms, details. Drawing here becomes the art of leaving
out.

One draws best what one knows best. The first thing
in America that "drew itself" for me was an apple
orchard on Long Island, which recalled one in Holland,
where I grew up.

I still feel most at home on those days when gray
clouds sail through the skies and shafts of sun make
islands of light in the meadows. For these were the
first intimations of the beauty of the earth for the
artist within the child. Did Rembrandt's life-long
fascination with chiaroscuro perhaps start with a
shaft of sunlight that fell through a narrow window
into the gloom of his father's windmill?

38

Every so often, I just have to return to Holland, drawn not by friends, by people, but by the flat meadows under the endless sky of my childhood. I have walked and skated through that landscape forever. I know it so well, I have it in my bones. Here nothing intervenes with what the eye perceives. The hand moves in perfect freedom and innocence. The landscape draws itself.

How lucky I was to be born in that little Dutch town, small enough to make all faces familiar, small enough to walk out of on paths along the river, into fields and meadows. And yet each tree, each house, each face, puzzled me, as if hiding some ultimate, crucial mystery, some impenetrable secret. Was the wry-necked cobbler in his hole-in-the-wall really a poet, a secret sage? The wry-neck, the squint, the hunched back gave me a special feeling, very akin to reverence. As a child I found these variations on the human theme oddly beautiful, started questioning the criteria, standards, scales, and rules by which the ME judges what is ugly and what is beautiful.

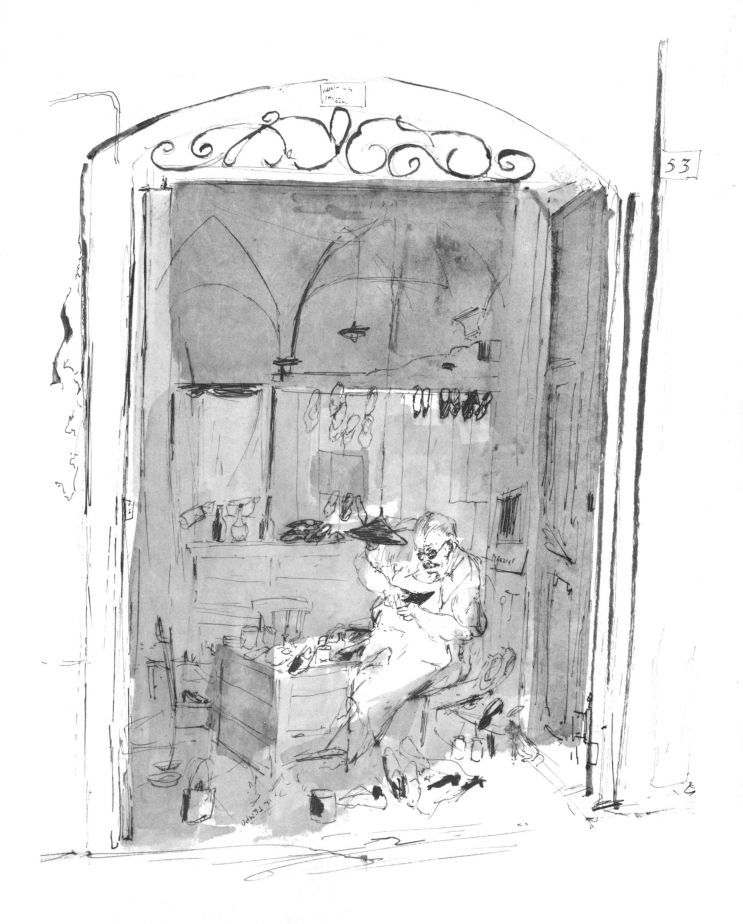

Years later when drawing in America, in Africa, in Asia,
in Australia, suddenly overwhelmed by human features,
vegetation, animals, architectural forms never drawn
before, the eye caught stagefright _ how does one
draw an African jungle?

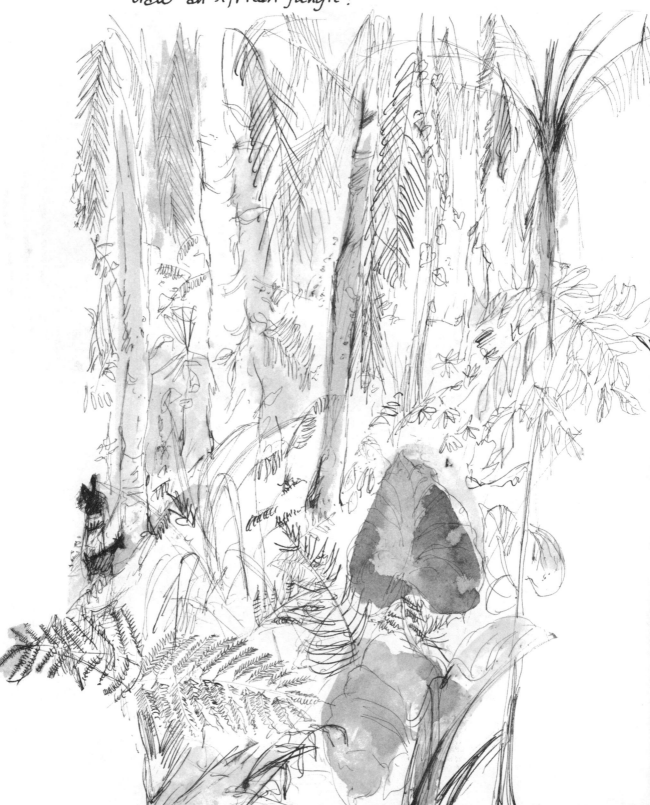

an emu?

a Noh - actor?

a wallaby?

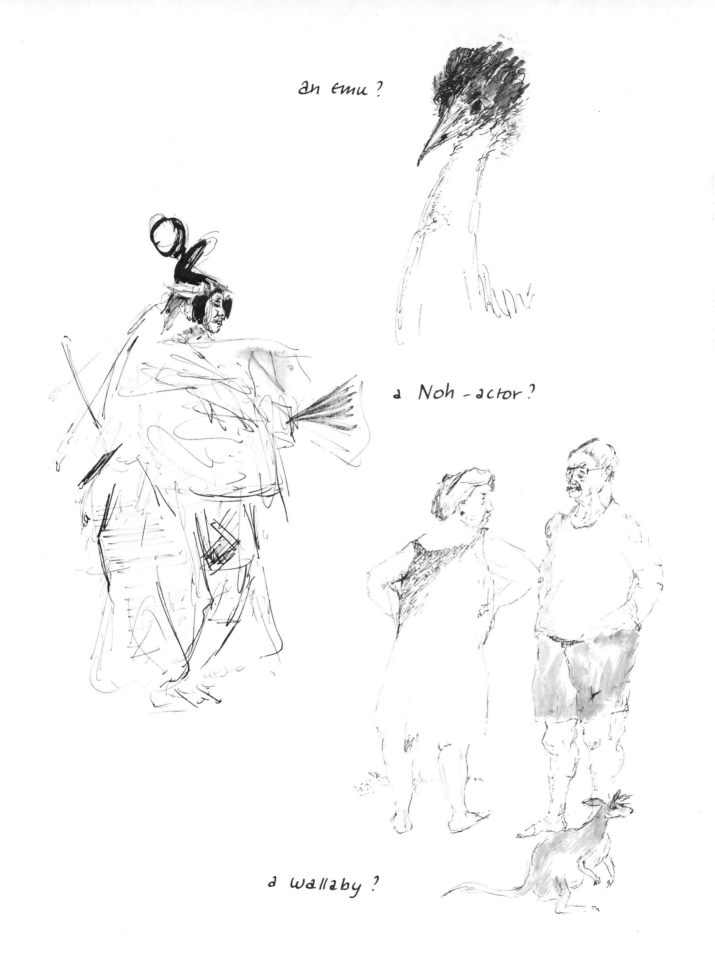

43

a Japanese market, an Ethiopian child?

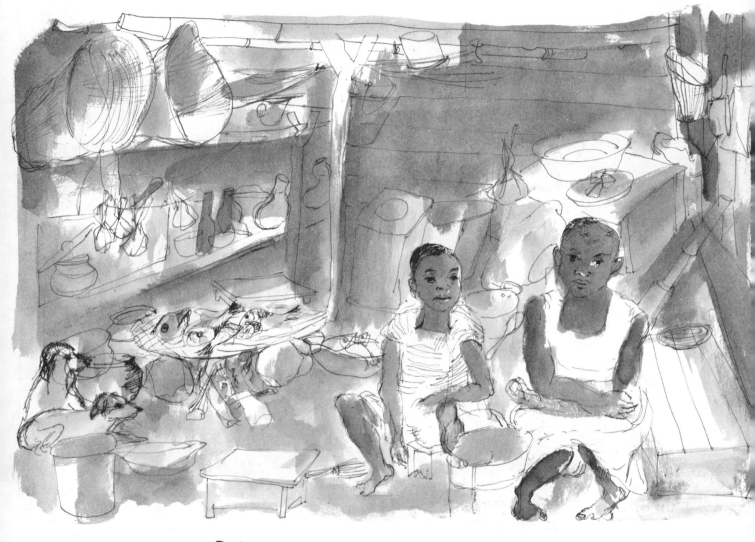

I learned: Just give the eye a little time to
overcome its panic, to calm down until
the hand dares trust it again, for alien forms
do not stay alien very long. THE EXOTIC DOES
NOT EXIST EXCEPT ON TRAVEL POSTERS...clouds and
trees, insects, birds, butterflies...and grass and gravel
underfoot... are everywhere, and

human faces, after all, disclose themselves as
being human very soon.

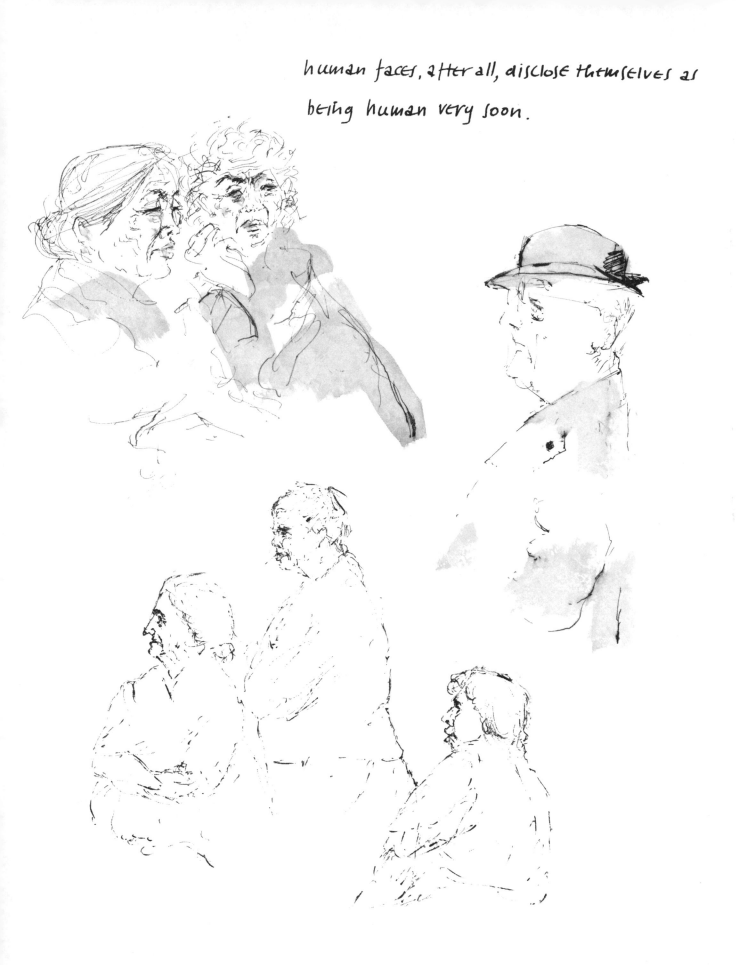

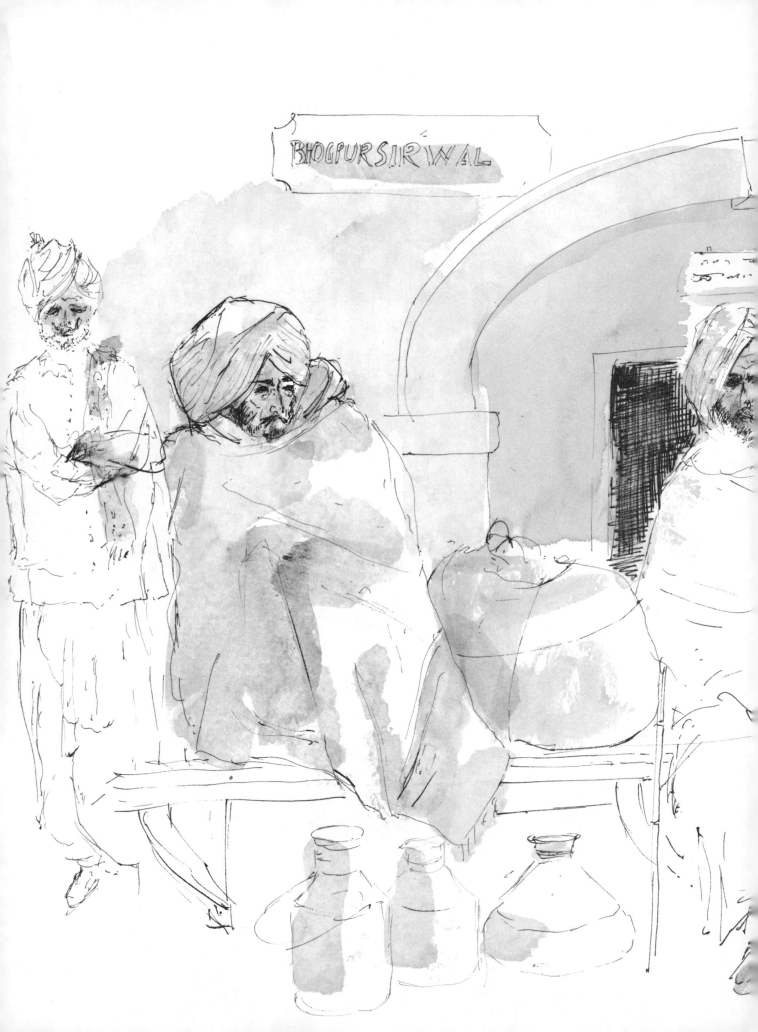

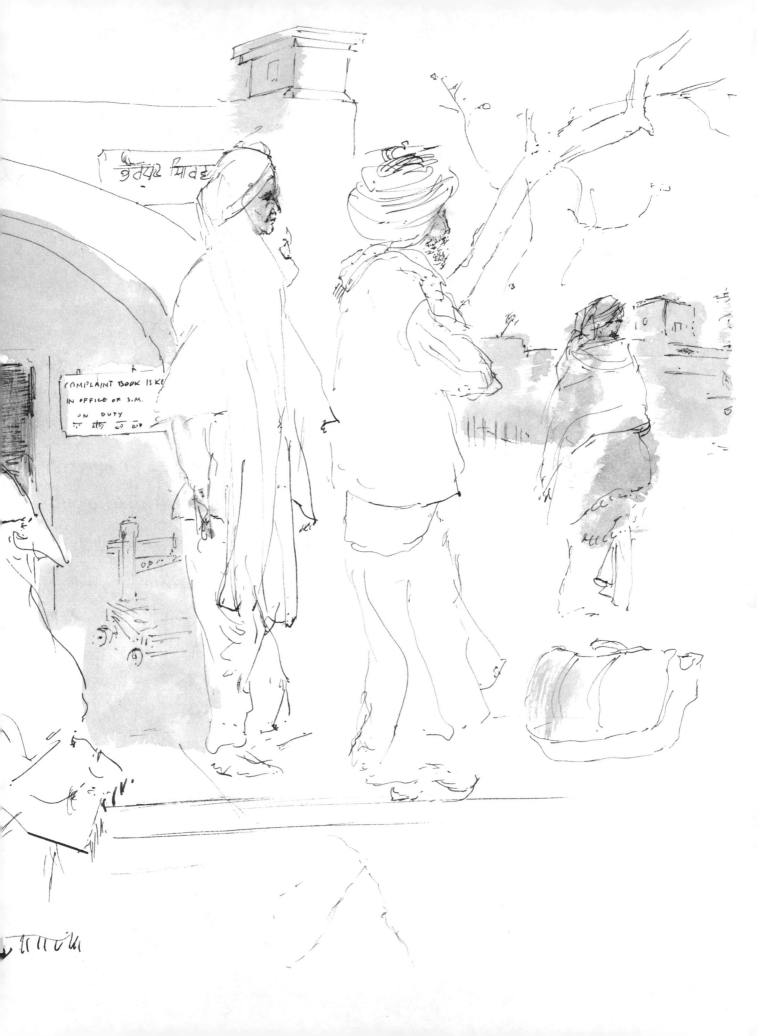

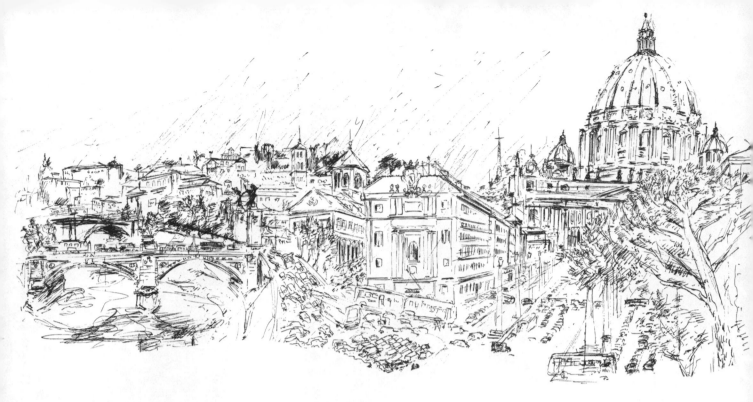

And the cities: Paris, Vienna, Tokyo, Rome, Delhi... they are
not just places I have visited, they have become home-
towns by SEEING/DRAWING. Each one has its own
atmosphere. How does one "catch" that atmosphere, so
that a detail from a drawing of Rome cannot be mis-
taken for one of Paris?

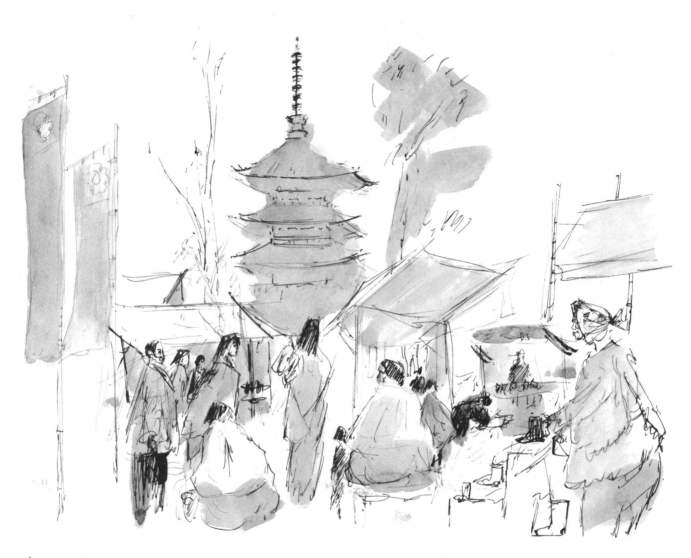

Atmospheres build themselves up out of a million imperceptible

micro-details, elements often too minute, too fleeting for

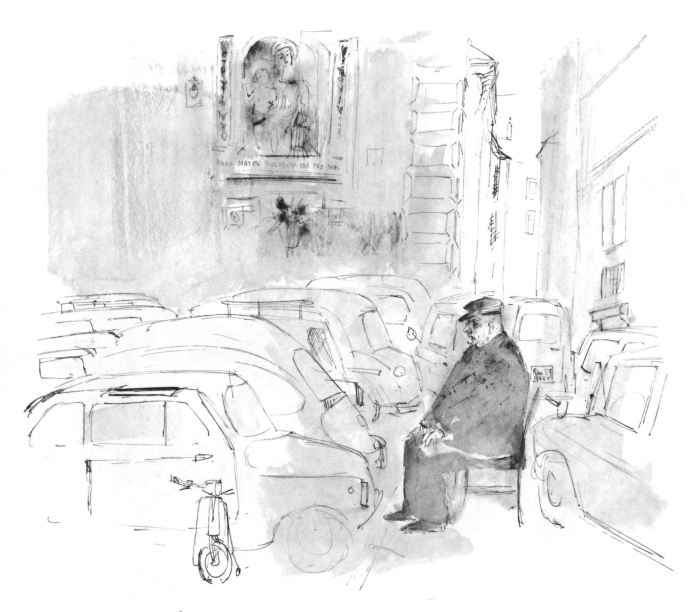

the conscious mind to pick up, but which the eye-heart-
hand reflex notes down, so that the buildings, and

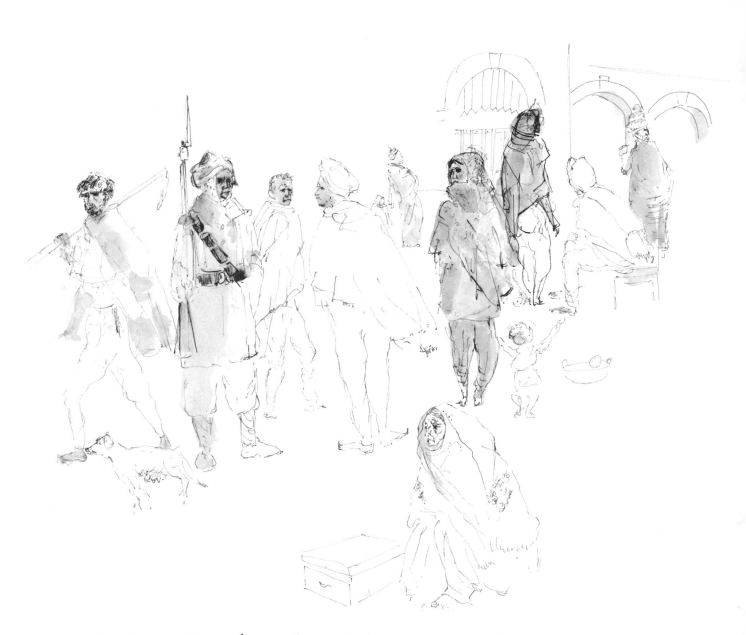

even the faces that form themselves on the paper, become
unmistakably Roman, Indian, Parisian, or Japanese.

When drawing this village near Amsterdam I had not been
aware of seeing, let alone drawing, the horse and wagon.

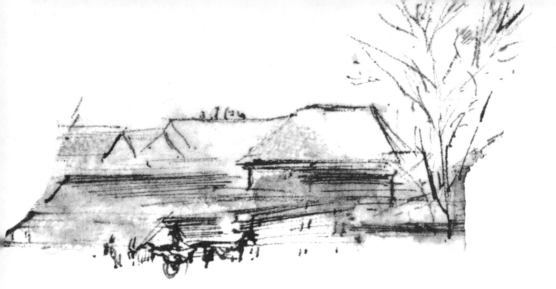

Only in the enlargement did I discover that the eye had observed it precisely and that the obedient hand had noted it down.

How, I am asked, does one draw animals — cows, horses, birds?
Since for me each new drawing is an adventure for which
I cannot predict the outcome, always — in a sense — my
very first one, I can give no recipe.

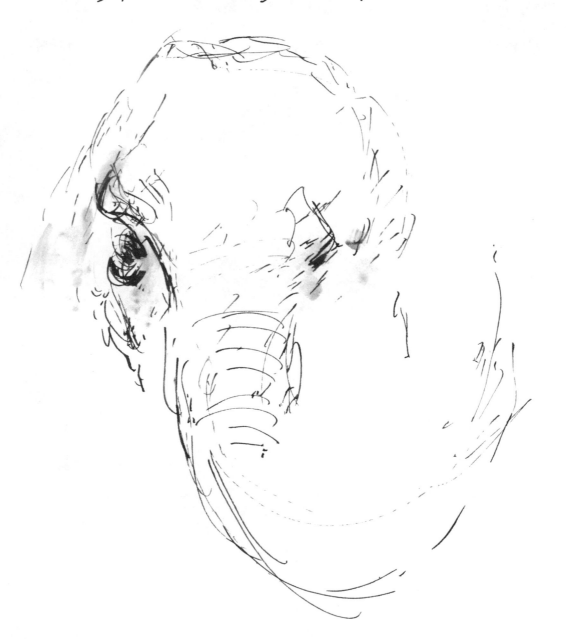

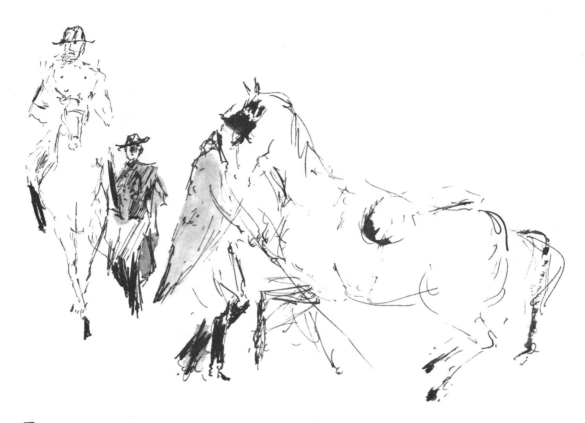

In the how-to books you will find horses reduced to their
"basic forms," to systems of ellipses or rectangles. In its own
way this may be useful for a picture manufacturer, but
it deprives you of knowing what a horse really looks
like.

In order to draw a horse, draw horses until you practical-
ly become a horse — not "horses in general," but always
that particular horse you are drawing at a given moment.
Until you feel the tense curving of its neck in your own
neck !

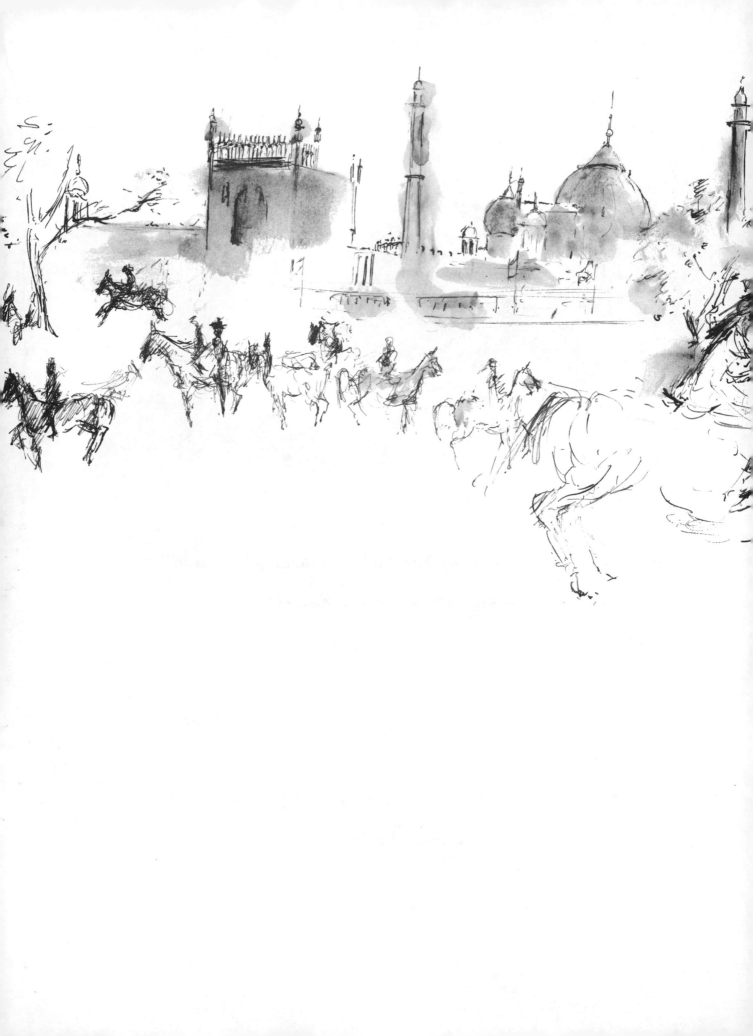

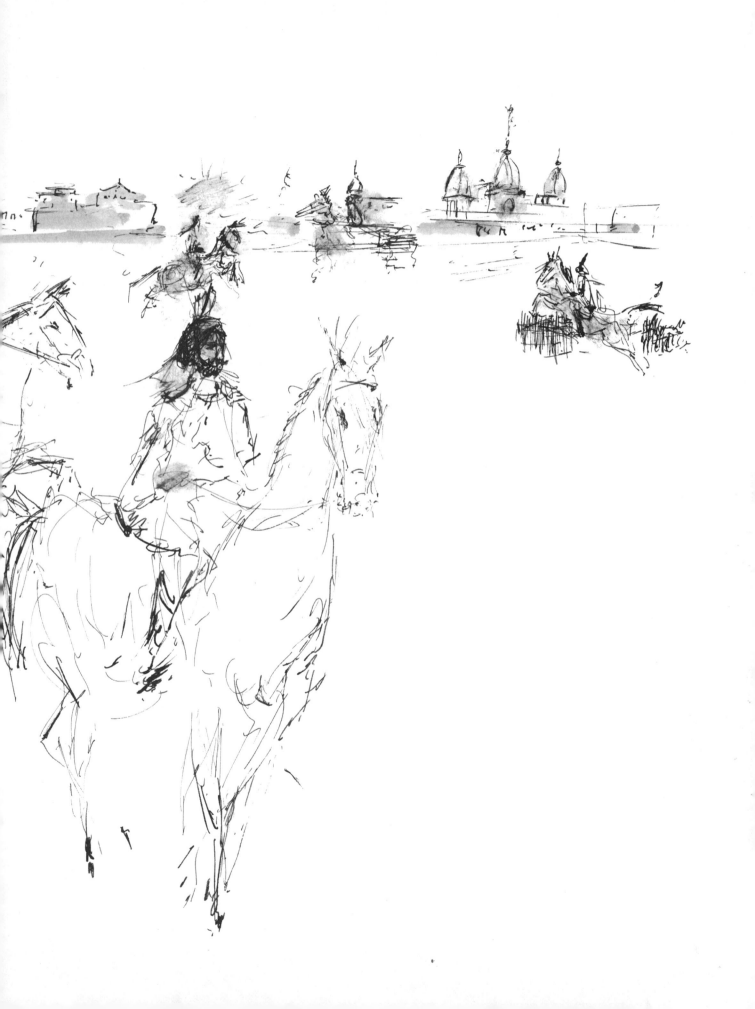

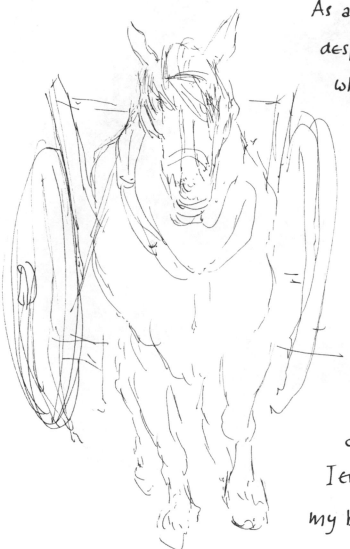

As a circus horse I have had to make desperate efforts to place my hind legs where the trainer so obviously wanted them. I tried to please my trainer. I wanted to avoid the whip's gentle reminder, which I felt more as a reproach than as pain... As an old cart horse I have felt dull and heavy, pulled my load in listless resignation. (Yes, I have been an ass, too... with extreme and distressing frequency... although I enjoyed carrying children on my back...)

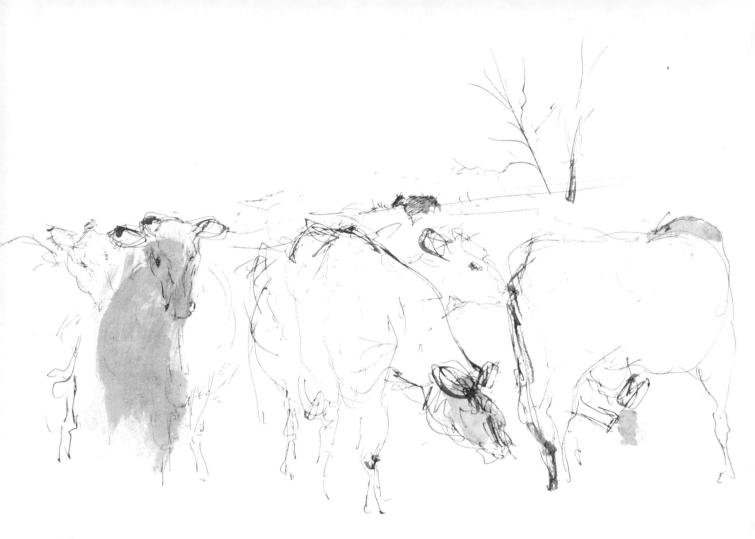

And I have been a cow, eyes all soul, tinged with sudden jerks
of fright and suspicion at that blinding white drawing pad,
have felt in my slow, contemplative cow's skull flashes of
warning, felt my eyes slide sideways, reconnoitering for
escape routes. No, a cow is not a rectangle on legs.

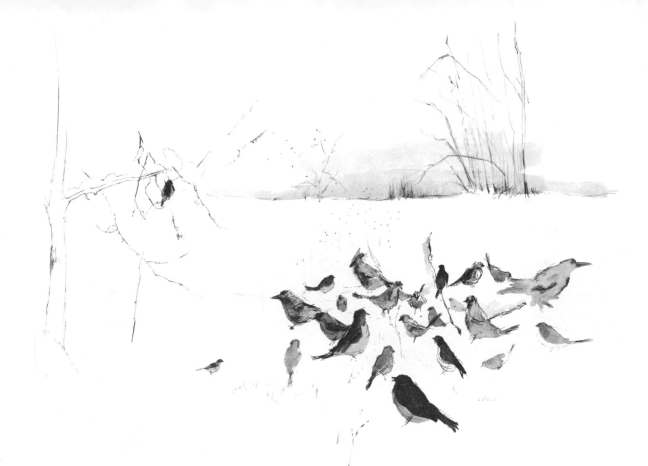

And how to draw birds? An ellipse with head and tail added?
No, a bird is all atwitter, achatter, and aflutter, alights
on short mini-trips, lands quicker than the eye can catch,
turns and twists its head in ultrafast jerks of interrogation,
decision, affirmation — is off again with a whiz of wing.
Birds are all ego, aggressively obsessed with a neighbor's
inch of worm, and they glare as if prepared to murder
for that fragment but are satisfied with a few harmless jabs
or wing blows . . . for they are not humans or rats. They don't
kill their kind. They don't devour their offspring.
If — as I hope — the how-to tricks with ellipses don't work for
you either, there is no other way of drawing a sparrow or an

eagle than to draw it ad infinitum, until the bushes on your
paper are fuller of birds than any bushes ever were, and you
know sparrow and eagle inside out, having been them yourself.
Then just wait, the man will surely come to label all your
birds for you : "That is a warbler, and that is a blue jay, and
that is a titmouse ..." I always forget which label fits
which, since I have been them all. But I do remember a
pigeon when I see one, for I never draw a pigeon without
recalling the pigeons of a neighbor I had as a child — a
pigeon fancier, who, slightly hunchbacked, stood on his
roof whistling until his birds came swooping down
out of the dove-gray clouds.

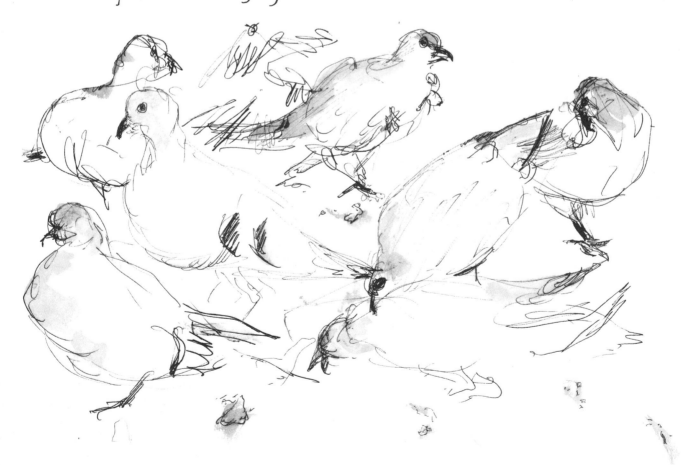

In the history of everyone in whom the artist-within has survived conditioning, schooling, training, there are persons, influences that have kept him alive, awake, who have encouraged him without even trying — just by being. They have been one's real teachers.

The first man I immediately think of was a salesman in a clothing store of my home town. On week-ends he sat drawing the old city walls — his tongue between his teeth, imitating every stone as faithfully as he knew how. He was apologetic about his drawing. "I am not an artist," he would say, "I just copy things." It was obvious nevertheless that drawing was not merely a hobby to him, but an all-important activity.

For him I felt an affection mixed with complicity, for he too differed from all those "others," especially the adults with their inexplicable preoccupations. I showed him my drawings. He studied them very seriously and said, " Don't stop, go on drawing. You are an artist." It was enough.

Another teacher who comes to mind did not draw at all. He was a rather forbidding lawyer, my father's attorney. One day we went to see him unexpectedly. When the maid showed us into the stiff drawing room he was sitting at his piano, so absorbed in a sonata that it took polite coughs to make our presence known. I was deeply moved, felt a sudden leap of love for this man. He gave me hope about growing up.

I felt a similar respectful affection for a local painter, a lanky fellow in a threadbare jacket who, in the noisy to-do of country fairs, stood sketching the lovers on the Ferris wheel, the children on the merry-go-round. In the milling crowd, with its compulsive gaiety and agitation, he looked to me as if he were the only sane human being.

Another teacher came to me much later. I discovered her in London when seeing her exhibition of marvelously sensitive drawings. She was virtually unknown. I found out where she lived and rang her bell.

A squat, middle-aged woman looked at me with suspicion.

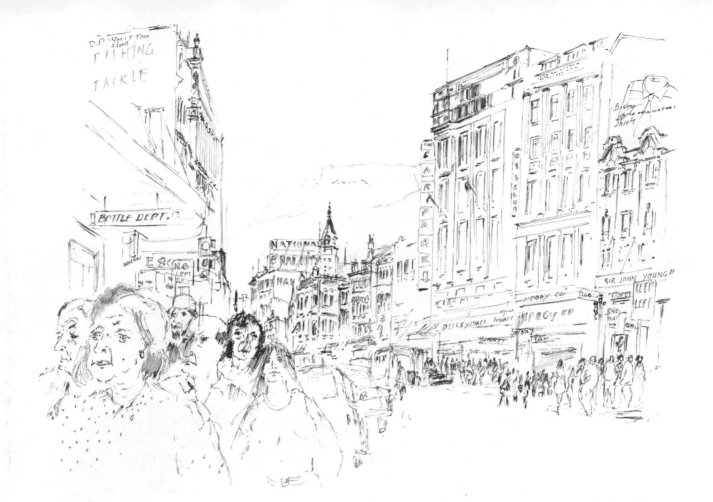

"I loved your show."

"Ah", she said, "you did? You really did? Come in!"

"Will you give me some lessons?"

"Bring me some of your work to look at."

Kathe Wilczynski looked at my drawings for a long time when
I saw her again. Then, in her heavy accent, she said: "I have
nothing to teach you. You must continue in your own way.
Draw and draw and draw! Now sit down,
I'll make you an onion omelet!"

All who were committed, authentic — that is, absolutely un-phony —
were my teachers. Without sentimentality they encouraged

me, insisted that what I was seeking I had to find myself, in myself.

One of these was the eighth-century master Hui Hai, who said: "Your treasure house is in yourself. It contains all you'll ever need." Someone else has said: "The Kingdom is within you..."

\Downarrow

"As for the skin,
What a difference between
A man and a woman.
But as for the bones,
Both are simply human beings."
 Ikkyu (fifteenth century)

In the city, where there are no trees, no grasses to draw, I draw in the museums, in parks where they seem safe enough, in railway stations, and at bus stops. Drawing all these people, sometimes the eye suddenly looks through their clothes. The fur coats, the hats, all the adornments, fall away, and at a party or in a department store all at once I see a mass of bodies in their nakedness, their mortality, their reality. It does not have a particularly erotic effect, this X-ray experience...

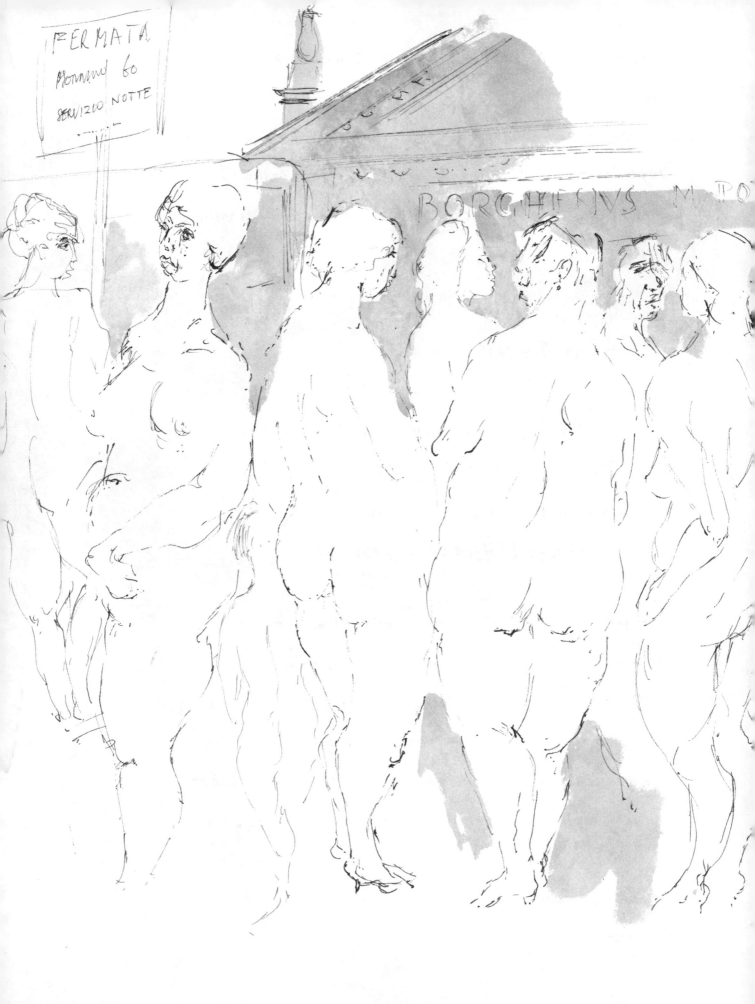

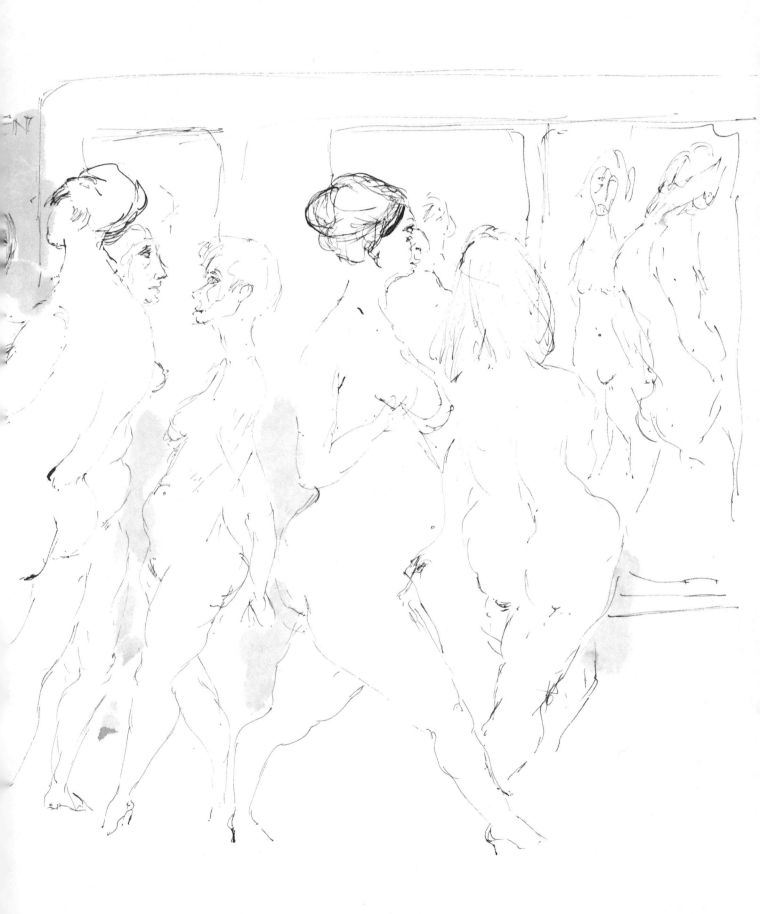

It probably happens because every week, for at least one long session, I draw "from the nude." I dislike this arty term, for the nude does not exist. It is simply the nakedness inside our clothes.

This nakedness I draw constantly because its challenges are infinite, and its study takes much longer than a life time. The fact is, it is never merely a naked body I am drawing, but a human being I am confronted with. Even when I succeed in drawing it well, so that it moves and flows naturally, is it alive with its own subjective life which I perceived to clearly while I drew it?

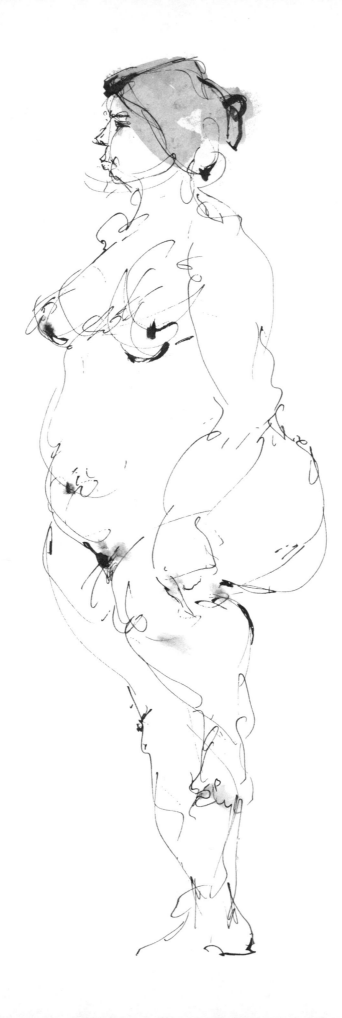

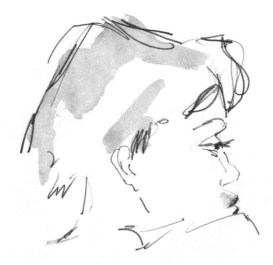

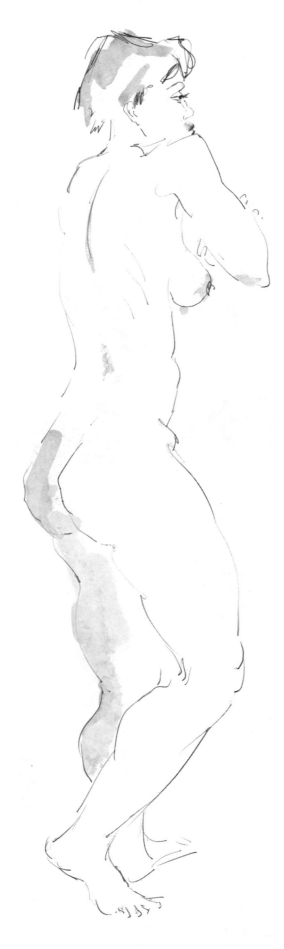

All textbooks on drawing from life counsel
not to concentrate on the face, but to
look for the large forms and masses and
how they relate to one another, to look
for structure and for movement. This is
very sound advice, but however hard I
try, I just can't help starting with at
least an indication of that particular
human face that belongs to that body
and gives meaning to it: It is this
human being I have to come to terms
with, or, more precisely, I have to
"become", to identify with.

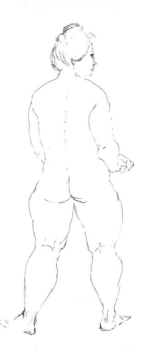

Everyone seems to know what constitutes "a beautiful body,"
a "good body." But, of course, a beautiful body is not one
with a set of prescribed ideal circumferences. The models I
love to draw are neither necessarily young, nor well-proportioned.
Pretty little things, smooth pin-ups and fashion models, with
all the right measurements, taking charming poses, may bore
me to distraction. Looking for the human being in this
smooth, posturing flesh, I find nothing but pretentious,
impersonal signalings: "Am I not lovely!" In the
human being, in the human body, it is the spirit that
informs the movement of every muscle.

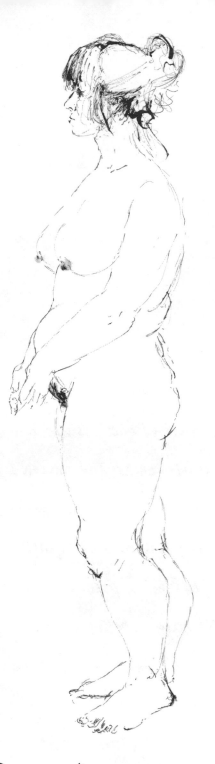

Drawing the naked body shows up every incompetence, every sloppiness, but especially every infantilism, vulgarity, love-lessness, callousness, of the person who draws. All peeping, all looking, all non-seeing, non-feeling, is caught red-handed. Show me your "nudes" and I know who you are...

How few even of the masters have drawn the naked body with
the awakened eye! Rubens's brilliant nudes are all meat.
Rembrandt's naked women are all compassion.
"Even before I can say it, it is no more," says Sengai, the
great seventeenth-century Japanese Draftsman. And this
is what Rembrandt saw: the human dewdrop evaporating
before his own consciously mortal eye, full of wonder, full
of reverence. He saw life as transitory and therefore as
of utmost preciousness. It is as if he had said to his model:
"We have faced one another for eons. How is it possible
we have never seen each other?" He saw the eternal
human condition in every human body he drew, painted, etched;
that is his unique greatness.

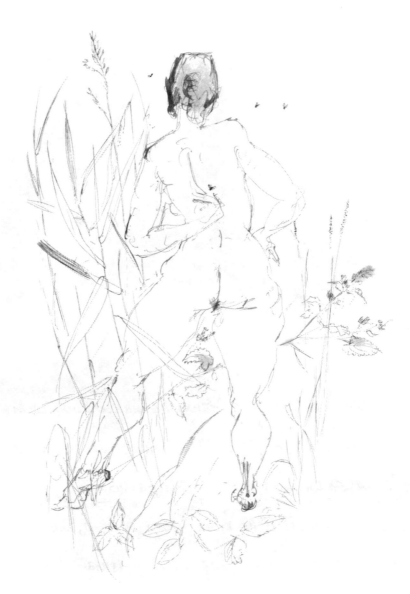

To see the human condition in the old woman, in the child,
in the model on the stand, in that particular human being,
and to let the hand trace it, this act of adoration is called
"drawing from life."

74

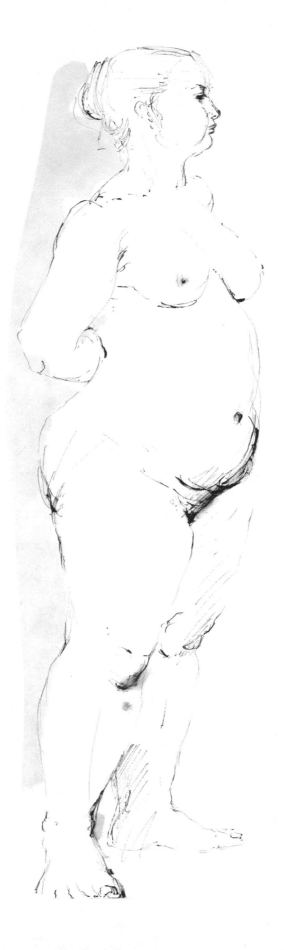

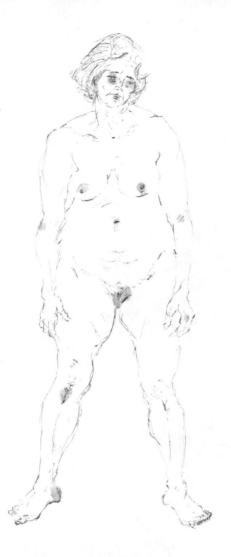

Older models, exhausted from the bearing of children, the scrub-
bing of floors, have been inexhaustible sources of inspiration
to me. One of these is a former ballet dancer. She is well
over fifty and earns a living for herself and a sick husband.
Her time-worn body still moves with such grace that a
hand never dangles dead by her side but is moved by
her spirit into exquisite gestures of fatigue, despair, or
resignation. Sometimes I draw this woman as the young
girl I still see in her. Then suddenly, I see her again in her beauty
as of an old olive tree...

"All that is left of her natural beauty,

Her skin is intact,

Her bones are as they are.

No need of paint and powder.

She is as she is no more, no less.

How marvelous."

IKKYU (fifteenth century)

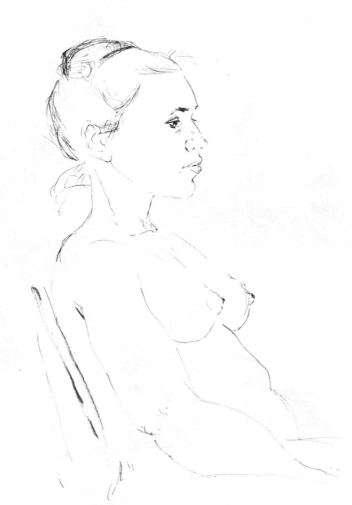

Then once in a while, in comes a dumpy girl in her street clothes.
She takes off her glasses, peels off her stockings, and stands
there in her strong womanliness — a revelation and promise
of tenderness, in her eyes the expectation of life's fullness.
Drawing her becomes a pleading — a prayer almost — that all this
expectation, all this promise, may not be squashed by life's
buffetings. Sometimes I draw such a girl and discover I
have drawn her as if she were already old...

This nude I am drawing is not just a body, not an abstract symbol
of youth or old age. She is the concrete person before my eyes:
this person. It is enough. To draw her is to let the perception
on my retina be affirmed by the hand that notes down in obedience.
It is not in any way "self-expression." It is letting the person
I draw express what she is, through me.

Drawing The Ten Thousand Things is being in touch, now and here,
with what is particular and universal, what is in time and yet
timeless, with the arising and the disappearing, with
birth and death.

As I am writing this, gnats and moths and mosquitoes, fatally
attracted by the mini-sun of my desk lamp, fly to their death.
I try to chase them away, shade the lamp, but they persist in
their suicidal urge toward the light. All the poignancy of The Ten
Thousand Things I SEE/DRAW in this small circle of light on
my table, in the vast, safe darkness of my studio.

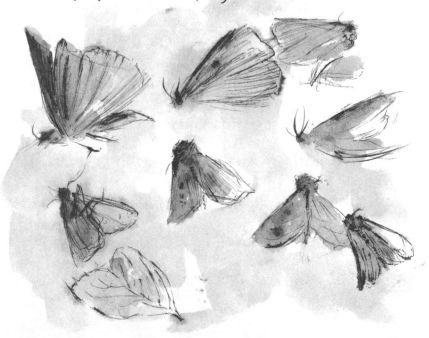

One tries to be so "strong," is so afraid of one's tenderness...

Yet what I see now, I once saw...

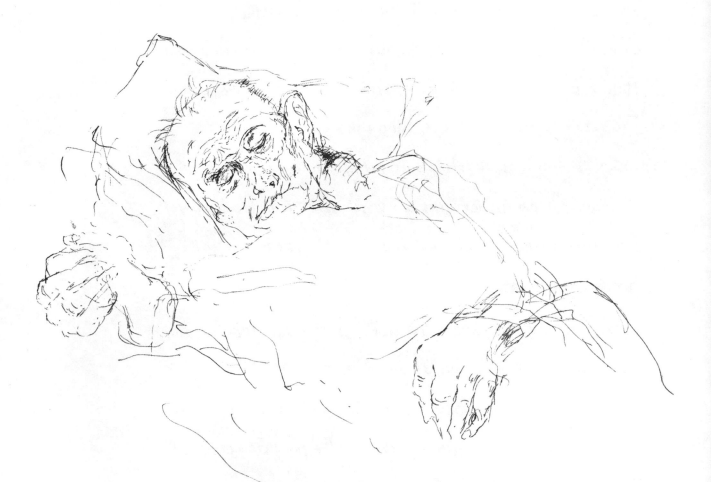

... while drawing an old man. He seemed to be sleeping

peacefully, and yet as I drew I noticed how all of him was in

constant motion. The hands on the counterpane opened and

closed, the eyelids contracted and relaxed, the chest heaved,

the nostrils jerked, the cheeks were drawn in and blown out.

Then, suddenly, my hand stopped. The sleeper had stopped moving.

... He had died. EVERYTHING MOVES CEASELESSLY UNTIL

THE MOMENT OF DEATH.

As always, from lonely death to life abundant: a crowd at an intersection — the most excruciating and exhilarating experiment in SEEING/DRAWING.

Faces loom up from nowhere, pass by, disappear forever. The hand moves as in fever, the paper fills up with these figures appearing from, being sucked back into, Nothingness, each one — like myself — disguised as a Me. Sokei-an, a contemporary Zen master, has said:

"I saw people coming towards me
But all were the same man,
All were myself."

And St. Nicholas of Cusa saw that "In all faces is shown the Face of Faces, veiled and as if in a riddle..."

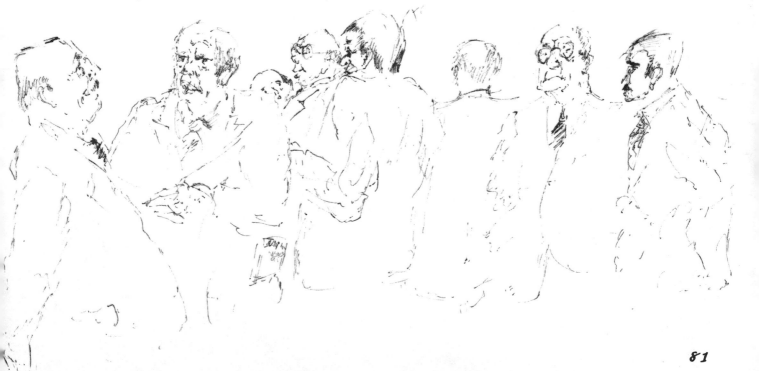

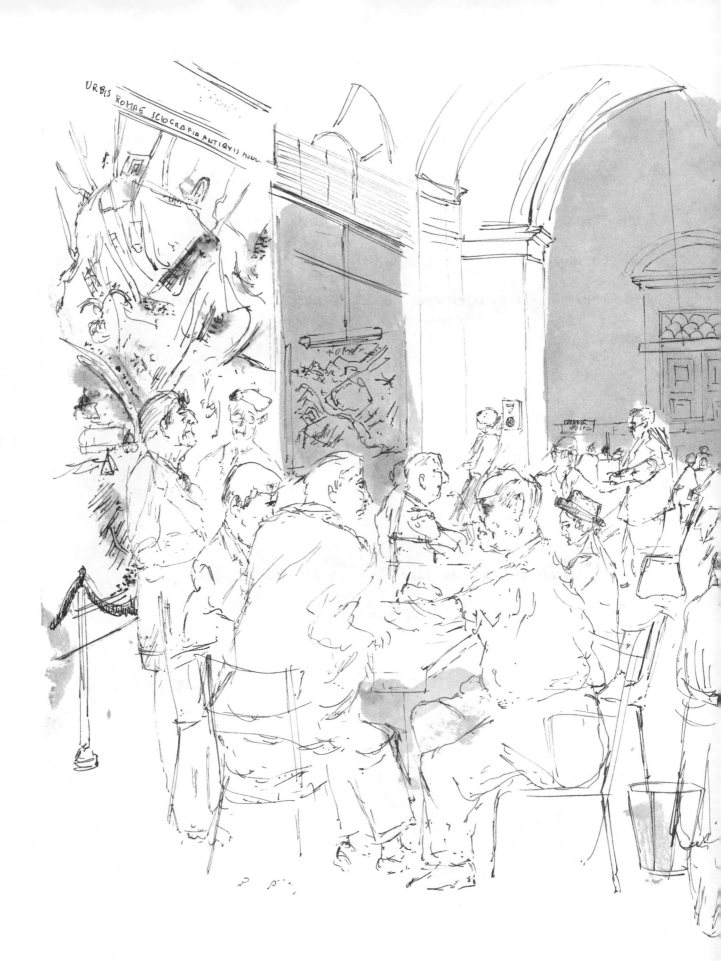

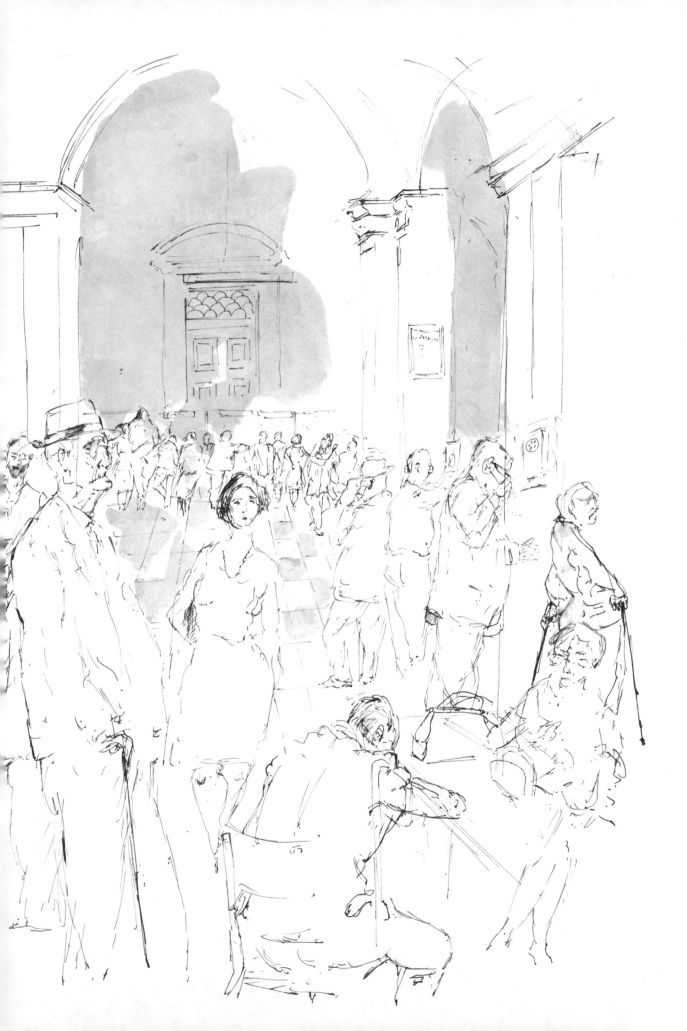

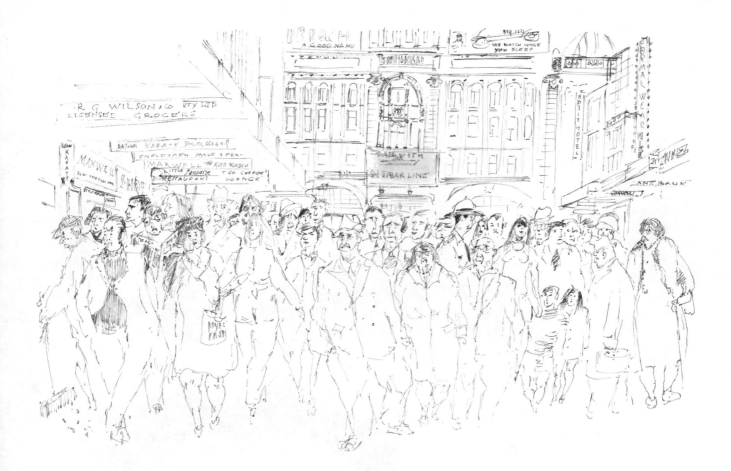

How to draw a crowd? It seems impossible to draw this
chaos in which every single element, every individual, moves
constantly. Perhaps the warp and the woof of the composition
is an instant vision, flashing in the mind the moment I begin.
The hand moves and keeps moving, jumping as in a dance; lines
without stopping move from figure to figure. As one of the
apparitions (real enough to himself!) moves out of the field of
vision, his after-image sometimes persists on the retina, so that
he has not really vanished yet and can be completed in absentia.
But more often heads are mated promiscuously with bodies
already gone. One woman's arm becomes another's.

Here I started scribbling the central figure of the old man in a hat in shorthand, related the surroundings, the architecture, to him by rapid indications in lines and dots. Then, while I remained keenly aware of the space in which the drama was played and of relative distances from the eye, radiating from this figure the other figures arranged themselves naturally, advanced, receded, overlapped. But at all times each one of these restless apparitions remained fascinatingly human to me with a life of its own, one which did not keep its position even for a split second in relation to all the others rushing around just as feverishly.

To my contemporaries, saturated with photographs of fighting mobs, football matches, demonstrations, these drawings are mere "pictures." They have no inkling of the mysterious process of SEEING/DRAWING a crowd, of composing all these figures in perpetual motion, integrating them in their architectural context as a living whole. To me, if it succeeds, the "picture" is an ecstatic experience: catching life on the wing in its Manyness, its Oneness — in cities, on beaches...

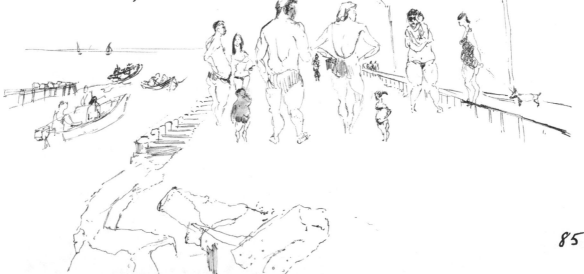

Perhaps I have given the impression that the moment I take pen in hand a stillness falls within, that the eye-heart-hand reflex can be switched on and off at will? Nothing could be less true. On the contrary, at the beginning of a drawing session I am more often than not in a state of acute agitation, even panic. The first few drawings I do of a model are often nervous scribbles, for the eye cannot focus yet, the hand doesn't obey. It is as if I collided with the model in mid-distance and we are having a fight. I resent her, find fault with her poses, her smirk, her frown, in an exacerbation of that "normal" hostility we reserve for strangers who make excessive demands on us. The Me, the ego, is straining too hard.... Sometimes this period of despair goes on for hours. Hand keeps fighting eye. The eye is shifty, it does not see—it looks. The brain meddles with every stroke. Then, provided I don't give up, I may yet overcome this horror, may lose that meddlesome Me, and something else may take over. That which is in front of me has its chance to make my hand move.

The hostile, touchy, idiosyncratic Me has calmed down. Something in the model at last begins to speak to me: the sadness of her glance, a birthmark perhaps. I SEE again! The eye no longer jerks in half-sleep. Anxieties, memories, daydreams cease.

At other times, when it all comes easily and I feel I am doing masterly drawings, feel in top form, I look at my harvest the morning after, quickly crumple it all up and throw it where it belongs, in the garbage can. If I don't draw for a week, the coordination is disturbed, the communication between eye and hand is broken. The hand refuses to be the eye's willing slave, is a dead weight at the end of my arm.

The good drawings I do are hardly mine. Only the bad ones are mine for they are the ones where I can't let go, am caught in the Me-cramp.

"If the good drawings are not yours, if it is not the ego that draws them, do you mean to say that they are done by the Absolute?" someone is bound to ask ironically.

That which draws in SEEING/DRAWING is that which I really am, but which I cannot possibly define and label. It simply defines itself by the way it draws. SEEING/DRAWING therefore is an impossible effort as long as the ego tries to force it. Once the ego lets go, it becomes effortless.

Emerson deflates the pseudo-originality the ego strains for: "What you are speaks so loudly, I can't hear what you say." A Zen sage has said: "You are putting a head on top of the one you already have"; and another: "To do a certain kind of thing, you have to be a certain kind of person."

In the bad drawings the parts remain parts. But good or bad, once a drawing is finished it should be forgotten. After all, it is only a fossil of experience — a fossil, however, that at any time can be resurrected by any eye that is sufficiently awake to follow the lines as process, to sense that A DRAWING IS NOT A THING BUT AN ACT.

If a drawing succeeds, be happy but don't congratulate yourself. If it is a miss, don't grieve over it but take a new sheet of paper. If some one praises a drawing, ask yourself what is being admired. Your drawing? Or the boats? Or the Moulin Rouge?

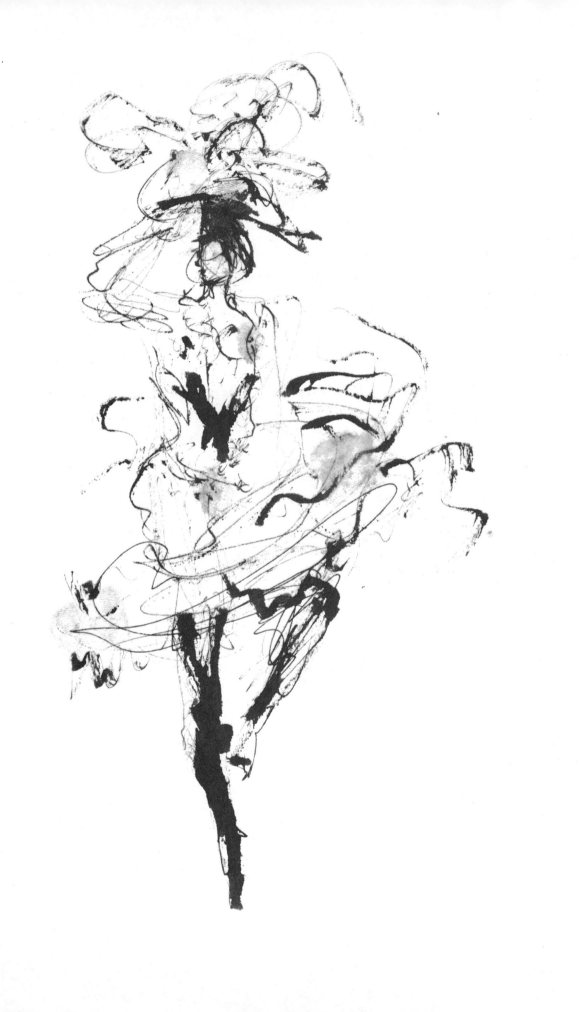

The Indian philosopher Aurobindo, who was also a poet, remarked that the consistent practice of an art in the end constitutes a kind of yoga. How true this may be I realized when recently someone asked: "Why do you whistle while you draw?"

I had been only half aware of it, but started to observe it, and noticed that indeed I whistle softly, more or less in the rhythm of a slow heart beat. Of course, it is an instinctive way of regulating breathing in order to "center," to detach myself from the noises of the surface mind... I also noticed how certain kinds of music interfere with my inner rhythm: I can draw to a fugue, to a waltz, but hardly ever to a march!

While observing this whistling habit, I also caught myself in something akin to prayer, or sometimes I talked to my pen to coax it: "... see, here it recedes, and there it curves around the bone, and there the skin is getting a little wrinkled..." Until the moment comes when all this is forgotten and the hand moves naturally, spontaneously, and I become the birdness of the bird, the knee cap of the model on the stand.

When drawing a face, any face, it is as if curtain after curtain,
mask after mask, falls away... until a final mask remains,
one that can no longer be removed, reduced. By the time
the drawing is finished I know a great deal about that
face, for no face can hide itself very long. But although
nothing escapes the eye, all is forgiven beforehand. The
eye does not judge, moralize, criticize. It accepts the
masks in gratitude as it does the long bamboos being long,
the goldenrod being yellow...

Sometimes drawings of faces are done quickly, almost sur-
reptitiously, but that does not make them sketches. In
sketching, the intellect chooses prominent features that
characterize an "object." In SEEING/DRAWING there
is no choosing : I become one with what is seen.

I have been told I smile when I draw a smiling face and
frown while I draw a stern one. No wonder, for I become
that face, often feel that I am looking at the man who
draws through its eyes.

The masks that peel off, one after the other, together form the "personality," which derives from the word "persona," the mask of an actor. In everyone these masks seem successively created by the "Me", and bear all the traces of attempts to hold on to this floating, fleeting "Me", to confirm it. The story of this clinging is told, for example, by the "personality mask" of the scientist, the professor, the philosopher, and the policeman - all character actors!

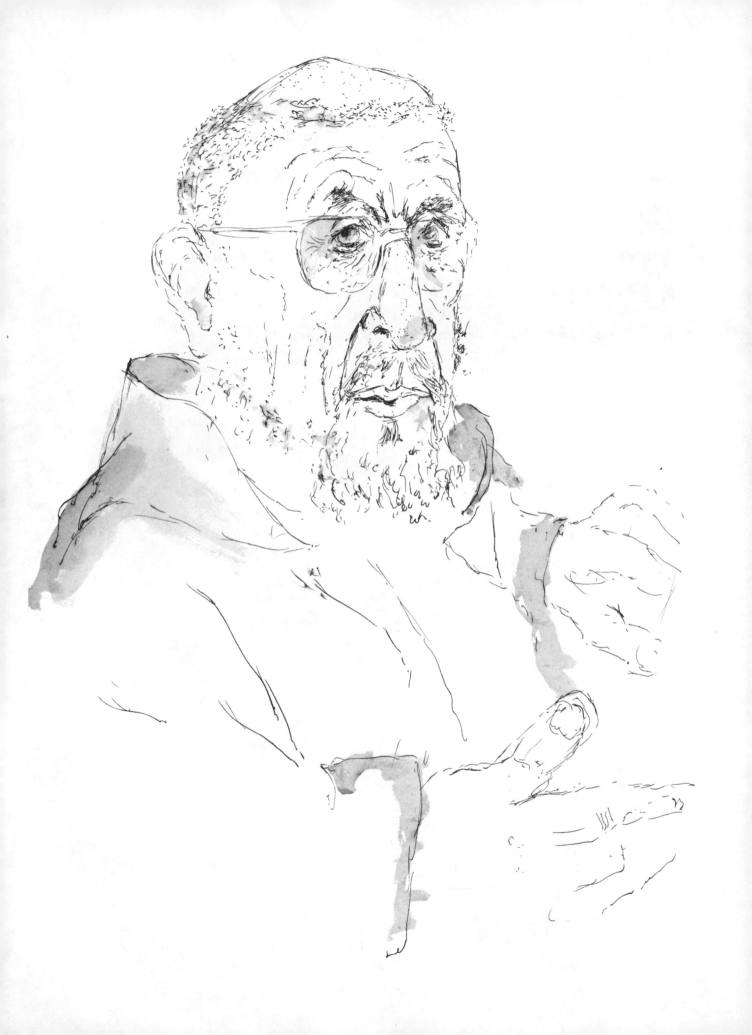

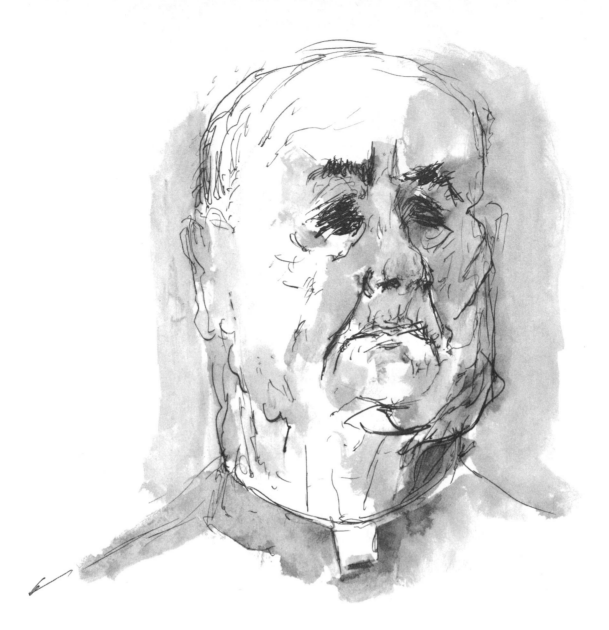

The energetic executive smile, the preacher's pious frown, the doctor's paternal smirk, the sweet-seventeen pout of the fading beauty — these are the top-layer masks that vanish at the first touch of relaxation, pain, or a double martini. Each "Me" is a succession of masks. At the moment of death, with the "Me", the last mask vanishes: "At last, with his dead face, he looks like a man," said Kenkobo, an ancient Zen master.

Albert Schweitzer became indignant when he noticed I was drawing him with his glasses on: "Don't, please, they make me look so old!" He was eighty-six... And a famous theologian demanded: "Before you publish that drawing I want to approve it! I want to check it as I do all my interviews." I respected his wishes; I never published it, not even for his obituary.

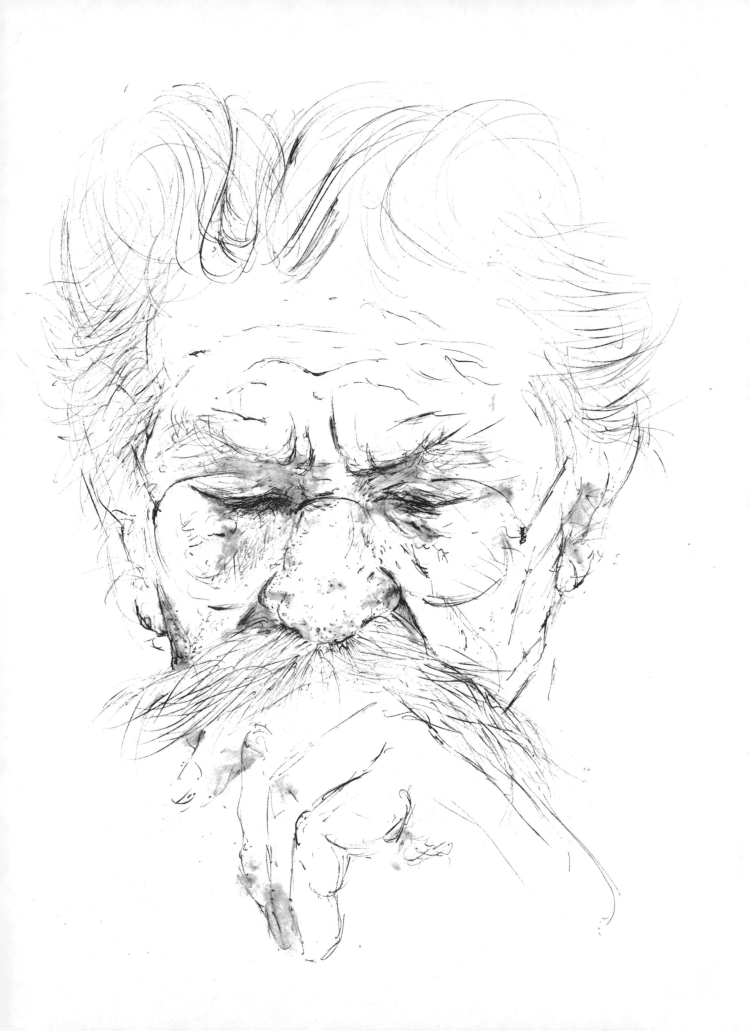

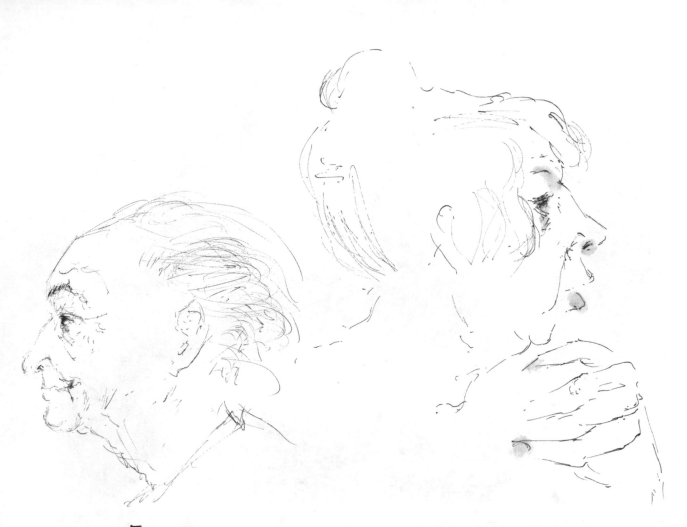

Each face contains all the mystery of the human, conceals
all that man is under its succession of masks...

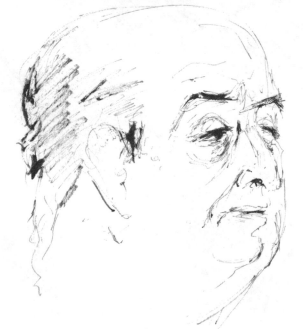

Only very, very rarely have I seen a face that—fully alive,
yet without mask—showed the human in all its greatness,
without a trace of falsity or pretense. It was in the face
of Angelo Roncalli, better known as Pope John XXIII, that I
saw this pure beauty of the Spirit. He was a fat man,
not handsome, but beautiful,
for he was a genius of the heart... maskless.

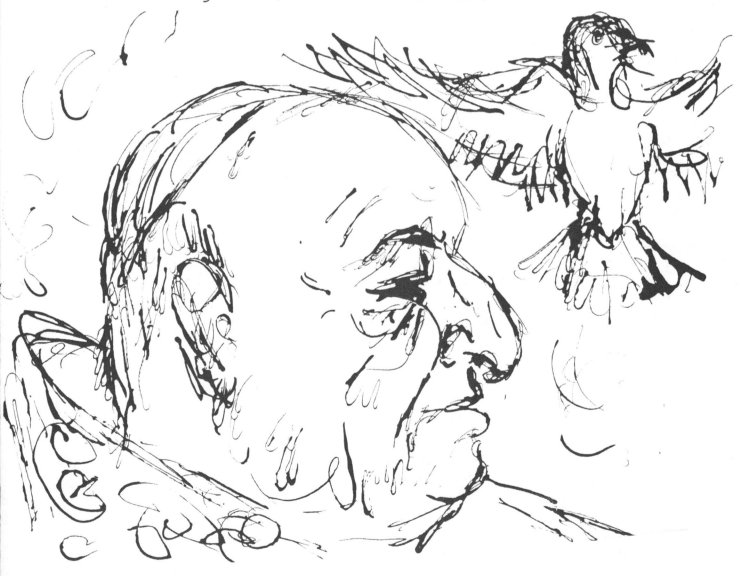

Sometimes it is unbearable, almost too excruciating, impossible, to draw someone you know very well, you love. Long ago

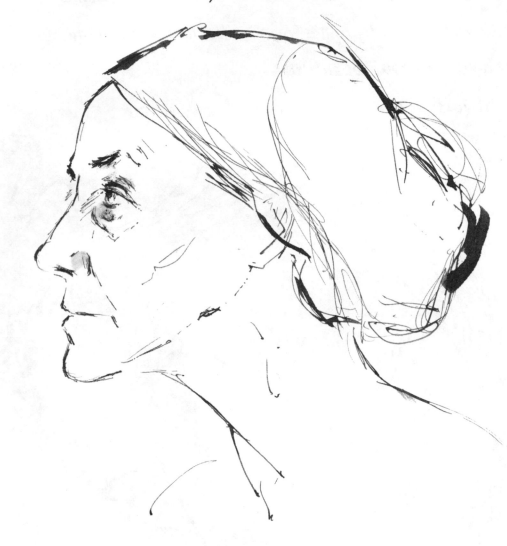

you have seen through the social mask the others see, have
seen all too clearly into the riddle of that face.

While drawing it, you see
 its vulnerability revealed,
 the first signs of aging,
 fading, disappearing forever,
 as a monstrously cruel
 unfairness...

While in Rome drawing the Vatican Council, I often drew Cardinal
 Ottaviani. He fascinated me. I saw him as a Grand Inquisitor.
 He was no Apollo. He was old and half blind. One eye was glassy,
 the other drooped. He had a confusing multiplicity of chins.
As I continued drawing him I began to see him differently. Where
 I had only seen arrogant rigidity and decrepitude, I saw
 the human being — until I realized that I was seeing him
 with a kind of love.
While SEEING/DRAWING a face, any face, one sees into the
 endless past of its ancestry, into the very center of human
 experience — of existence as such: the one ineffable

mystery. The experience of this ultimate mystery is what Buddhists speak of in negative terms as Sunyata, or Emptiness, or in positive terms as Tathagata, or Suchness. Sunyata is an Emptiness so full of potentiality that all emerges from it, all is reabsorbed in it. Behind all a man's masks there is the irreducible mask of Sunyata, of this Emptiness: "There is no here, no there. Infinity is before our eyes," says the seventh-century Zen patriarch Sentsang in his Hsin Hsin Ming.

And here we are back at the very heart of Zen, about which hardly anyone can speak, as it is beyond words, beyond language, hence all too easily distorted and misrepresented. "Say the word Zen and your whole face is red as a beetroot with shame," says a Zen classic. And: "After you have said the word Buddha, go and wash out your mouth!" counsels another.

Still, red as a beetroot, I must dare and stammer a little more about Zen, for I find it all-important.

When, years ago, I first discovered Zen writings, I did not find them strange. On the contrary, they confirmed and clarified my most intimate intuitions about life. It was like discovering a strange country, and in this strange place one happened to know the roads and hills and ponds. It was home.

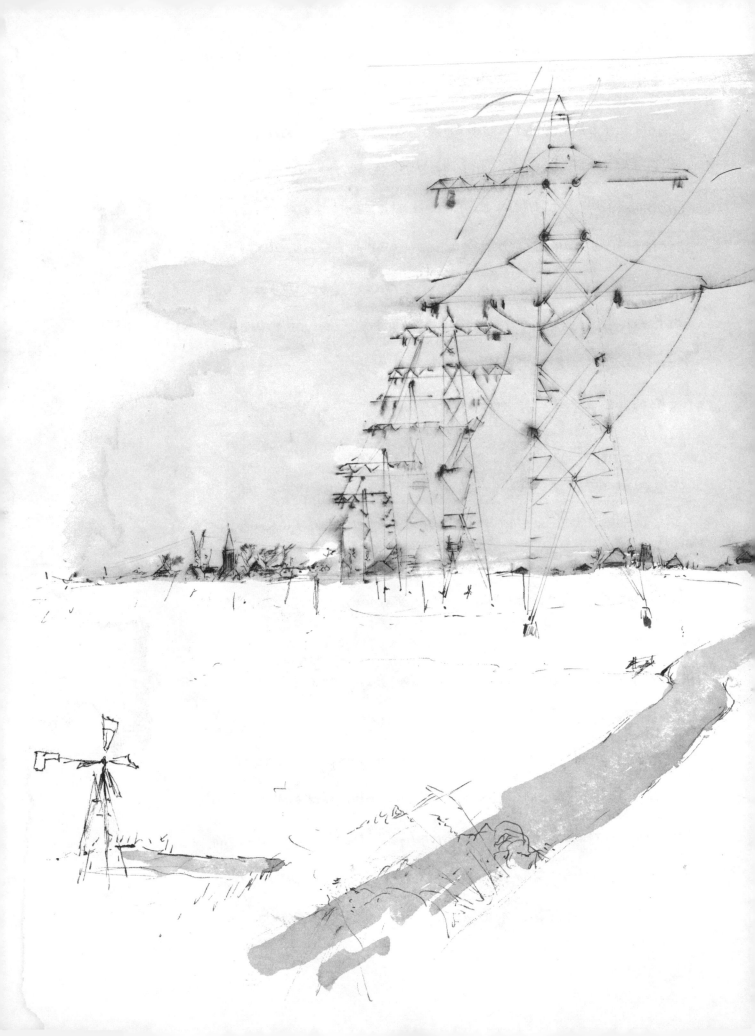

Bodhidharma, who according to legend brought Ch'an, or Zen, from India to China, is said to have defined the fundamental principle of Zen as:

"A special transmission outside the scriptures;
No dependence upon words and letters;
Direct pointing to the heart of man;
Seeing into one's nature and the attainment of Buddhahood."

What is called "Buddhahood" has through the ages also been spoken of as the "True Self," the "Essence of Mind," the "Original Face," the "Cosmic Unconscious," the "True-Man-Without-Label," the "Heart," the "Buddha-nature," the "Unborn"...
Its awakening has been called "realization," "Enlightenment," "Satori," or in Christian language the "birth of God in the soul"— something not to be experienced sometime later in a distant future, but now/here, in the present. Hui-Neng says:

"The ordinary man is the Buddha.
One foolish passing thought
Makes one an ordinary man,
While one enlightened thought
Makes one a Buddha."

Apart from this "Essence of Mind," or "Heart," there is no Buddha anywhere "out there." The "seeing into one's nature" is _not_ an intellectual self-analysis. It cannot be described in words. Words can only point in the right direction. To strive for Buddhahood or to run to some Buddha for solutions and "Enlightenment" is to move in the wrong direction. "If we seek the Buddha outside the Mind, the Buddha changes into a devil," says the thirteenth-century master Dōgen. Dōsan, in the same century, wrote:

"Whatever I may be
I meet him.
He is no other than myself
Yet I am not he."

This "no other than myself"— which at the moment of this writing I am not—who is he?
The Zen master Rinzai — who in the ninth century founded the Rinzai sect, still the most vital one in Japan today — indicates this in a story. The story opened the very spirit of Zen for me as it relates to my own life, for it was like a déjà-vu. Something I had always vaguely known was confirmed, brought to full awareness by it.

Rinzai said to his students: "In the mass of red flesh there is the True-Man-Without-Label (or "rank", or "title," or "status"). He is constantly going in and out by your facial gates (your six senses). Those of you who have not yet seen him: See!"

A monk asked: "What is this "True-Man-Without-Label?""

Rinzai came down from his pulpit, grabbed the monk and shouted: "Speak! Speak!"

The monk was nonplussed.

Rinzai pushed him away and shrugged: "This True-Man-Without-Label is just a piece of dirt," he said and went back to his room.

What could be the correct answer to Rinzai's "Speak! Speak!"? Since I am not that monk, I can't answer for him. But for myself? I grab my pen and draw! The Suchness of things calls out, calls me by name and shouts, Speak! Speak! I respond, I draw.

Where this True-Man-Without-Label is awakened, the Buddha is present and "I am before Abraham was," and before scripture was written: at the root source of all revelations, where all men are totally equal. On the other hand: "If your eye is just a little clouded, flowering illusions are rampant," said the ninth-century master Kisu.

So there is nothing misty or even "mystical"
about Zen. It is not unrealistic, not
surrealistic, but is an absolutely realistic
way of perceiving the world in both
its Oneness and its Manyness.

111

Zen raises the ordinariness of The Ten Thousand things to sacred-
ness and it debunks much that we consider sacrosanct as
being ordinary. What we consider supernatural becomes
natural, while that which we have always seen as so natural
reveals how wondrously supernatural it is. Where Zen
speaks of "Buddha," it does not point at the historical
personage to be adored, followed, or imitated, but at the
inmost specifically human nature of man, at the True Self,
at the True-Man-Without-Label, awakened. There is no Buddha
to be found anywhere else. It is the "Buddha-heart" that
knows God, even if Buddhism keeps quiet about "God"...
As to Zen's declaration of independence from Scriptures, this
is not an expression of contempt. It simply stresses that
the repetition of even the wisest, most hallowed words

cannot deliver us from the ego-trap and its delusions. Scripture, unless read by the awakened spirit, by the True Self, is mere printed matter.

This declaration of independence from words, from holy jargon, is probably one of Zen's greatest attractions in a time when words — which at best can only express part of the truth — are manipulated by political and commercial propaganda to the point where they have lost all meaning. Where Zen uses words it does so in the awareness that they are like fingers pointing at the moon, not to be mistaken for the moon itself.

He who sees, understands Christ's "I am the Light of the World" and Buddha's "I am the Eye of the World." And he who knows it is all in the SEEING, understands from the Upanishads: Not what the eye sees, but that which makes the eye see, that is the Spirit"; and : "Truly, oneself is the Eye, the endless Eye."

The Zen attitude to life is not absorbed from books, although it may be confirmed by reading. It is the inborn attitude of the True-Man-Without-Label, who may well be the artist-within...

The first intimations of Zen, of the opening up of the eye, of the revelation of The Ten Thousand Things, come early in life. Everyone must be able to recall revelations similar to mine. I have no monopoly.

On a dark afternoon — I was ten or eleven — I was walking on a country road, on my left a patch of curly kale, on my right some yellowed Brussels sprouts. I felt a snowflake on my cheek, and from far away in the charcoal-gray sky I saw the slow approach of a snowstorm. I stood still.
Some flakes were now falling around my feet. A few melted as they hit the ground. Others stayed intact. Then I heard the falling of the snow, with the softest hissing sound.
I stood transfixed, listening . . . and knew what can never be

expressed: that the natural is supernatural, and that I am the eye that hears and the ear that sees, that what is outside happens in me, that outside and inside are unseparated.

It is the inexpressible, and THE INEXPRESSIBLE IS THE ONLY THING THAT IT IS WORTH WHILE EXPRESSING. Therefore I draw; therefore, now, I am writing this.

Recently I found in a Zen book a poem by Hakuin, a great artist and sage of the seventeenth century:

"How I would like people
To hear... the sound of the snow falling
Through the deepening night..."

I read this poem during the last days of my friend Nora, who lay dying of cancer. Just before she died I saw her eyes drifting to the scrawny sumac outside her New York window. They suddenly focused, became enormous, ecstatic.

"Look, look," she whispered, "it is still moving!"

When Fa-chang was dying, goes the story, he heard a squirrel screeching on the roof. He murmured: "It is just this and nothing else..."

I draw a leaf... Still it is moving. Still the birds are on the wing. Still I can hear the silent falling of the snow... Some of the grasses are long, others are short...

Zen stories take their own time to sink in, to penetrate one's whole being, for they are not beamed at our thinking capacity alone. It was the Rinzai story which, in the end, disclosed to me who my teachers had really been.

What or Whom I had glimpsed in the lawyer, in the shop-assistant, and in the poor young painter at the fair— who else could it have been but the True-Man-Without-Label, the fundamentally, truly human being in man?

And who was it who had recognized this? Who else but the True-Man-Without-Label in the disguise of the child I was then? For he is not a figment of the imagination, he is neither Eastern nor Western, but man's most absolute subjectivity and most universal reality... every-where and in every culture— and always hidden, veiled, disguised. This True-Man-Without-Label, this True Self, can only be GLIMPSED and EXPERIENCED— or, if not experienced, denied or ridiculed. It is our true identity. In Zen it is called the "Buddha-nature." Is this so different from "the divine in man", from the Spirit of Christ?

A monk asked his teacher: "What is my Self?"

The teacher answered: "There is something deeply hidden within yourself, and you must be acquainted with its hidden activity."

The monk then asked to be told what this hidden activity was. The teacher just opened and closed his eyes.

It is the opening and closing of the eyes that is Zen. But this has to be pondered in the heart, as with all that is worthwhile it can only be revealed but not explained.

One day I stood in the grottoes of Lascaux, France, where thirty thousand years ago the cavemen of Aurignac had drawn the magnificent bulls on the rock walls. Face to face with these most ancient of drawings, I saw how these pre-historic artists had seen directly into the very life-center of the animal, had grasped it with the full humanity of their eyes and hands. Here the True-Man-Without-Label was already at work in SEEING/DRAWING, giving his answer to Rinzai's "Speak! Speak!" Zen and

Culture were already present, and from Lascaux, via Vedas and Upanishads, via Gospels and Sutras, via Chuang Tzŭ and Lao Tzŭ, Buddha and Jesus, Hui-Neng, Rembrandt, Bach and numberless others, mostly forgotten, the True-Man-Without-Label — our deepest longing, our own reality — speaks to us.

SEEING/DRAWING is, beyond words and beyond silence, the artist's response to being alive. In so far as it has anything to transmit, it transmits a quality of awareness.

It is beyond words, beyond silence — for the True Self cannot be expressed by either the use of words or of silence. "What is the eye of the one who never sleeps?" the disciple asks. "The physical eye, the ordinary eye," the master answers. It is the eye of the True-Man-Without-Label, the Buddha-eye, the Christ-eye, the "eye with which I see God" and which is "the same eye with which God sees me"...

The sense perception, the activity of the reflex eye-heart-hand, is still, as in Lascaux, the leap from a platitudinous world to one of mystery. All is suddenly suffused with meaning. Once this leap has been made, once wonder and awakening have flashed upon us, we inevitably fall back into our half-sleep—but with a difference, for a radical change in perception and feeling has taken place. Through the multiplicity of forms and appearances the Structure of Reality was mirrored, and disclosed itself, unconfused by concepts, opinions, labels, and prejudices. The relatedness between self and the universe has been restored. But the ego cannot WILL this to happen: its shell has to be broken through first.

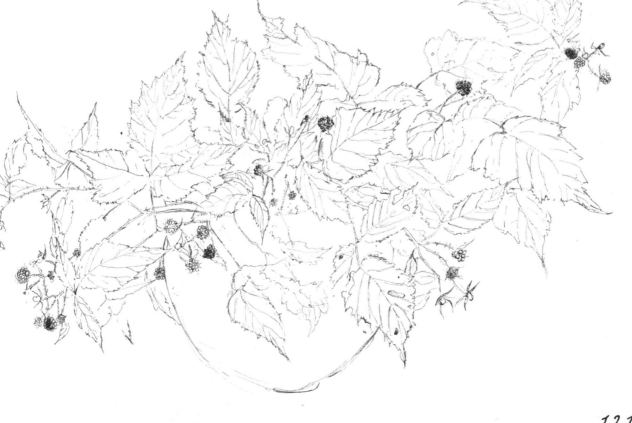

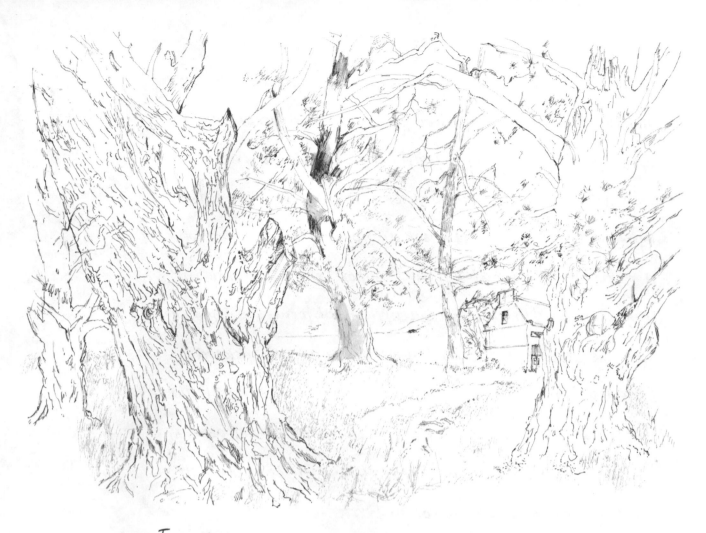

I want to say something about what I discovered to be valid
for me, even though I am not sure it is valid for everyone.
It concerns photography and painting, both of which I
abandoned when in SEEING/DRAWING I found an art
more urgent than art itself.

I had painted and exhibited for years. I folded up my easel,
closed my paintbox, when I discovered that it was not really
my aim to add to the world's stock of art objects, dis—

covered that what I really wanted was to truly SEE before I die. And so I started to draw as if my life depended on it. It very probably did—and does.

Painting, for me at least, had always strengthened, exalted the ego, the ME. Drawing—especially with the merciless pen—constantly shakes it to bits . . .

Nor could I combine photography with drawing. Drawing required a different kind of seeing. Pressing the button is, of course, incomparably better than walking through the world with dead eyes, but how easily it becomes a substitute for seeing,

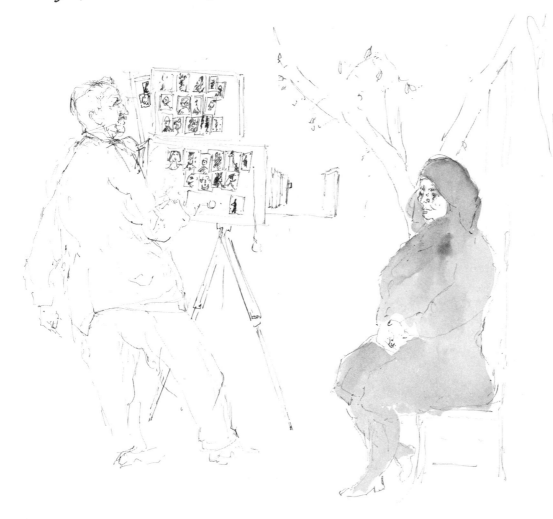

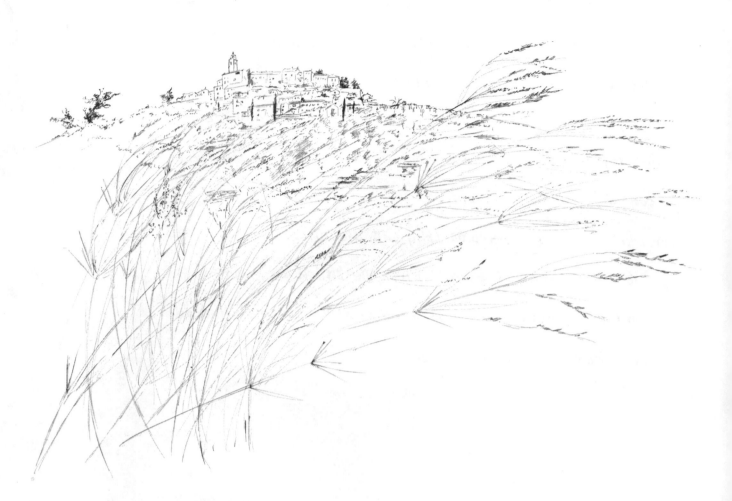

remains stuck in "looking"! For my purpose, the shutter
clicks much too fast. I have found that in order to SEE
I must allow my eye to rest on a commonplace thing—a face,
a stone, a weed (of course, the category "weed" was invented
by the Me, and a dandelion is in no way inferior to an orchid!)
— in order to experience it with all my senses, with nerve
endings bare.

While I am SEEING/DRAWING, I take hold of the thing,
until it fills my total capacity for experience. Once I have
thus taken possession of a hill, a body, a face, I let go,
let it go free again, as if I were releasing a butterfly.
Yet it remains mine forever. After much SEEING/DRAWING
my eye goes on Drawing whether my hand draws or not.
From morning till night, my eye draws The Ten Thousand
Things.

Chuang Tzŭ said, in the fourth century B.C.:

"The perfect man uses his mind as a mirror. It grasps
nothing, it refuses nothing. It receives but does not keep."
Indeed, it mirrors the tree in Joshu's courtyard, the face
in the subway, the naked body bending, the glazing
over of the dying eye, the lovers intertwined...
all Ten Thousand Things.

But being far from perfect, what happens when I do more than just mirror? All that is added is Me-assertion, is Me-expression, which we misnomer "self-expression" and are so proud of. It is that "personal style" that assumes it is more important than letting that which is seen express itself through the hand that draws — but does not "copy"...for it is moved by the reflex that comes to it from the eye through the heart.

The French painter Gustave Courbet insisted: "Wherever they put me, it is all the same to me." This reminds me of the old Zen saying: "Choosing to set up what you like against what you dislike,

is the sickness of

the mind" and

"There is nothing difficult about the Great Way, but
 avoid choosing."
Cézanne pretended — in theory — that the essence of an
 apple is a ball shape. But since his eye, his hand, and his
 heart knew better, he painted apples that were all
 applishness. . . The seventeenth-century Zen master
 Sengai's drawings were so full of humor that he was

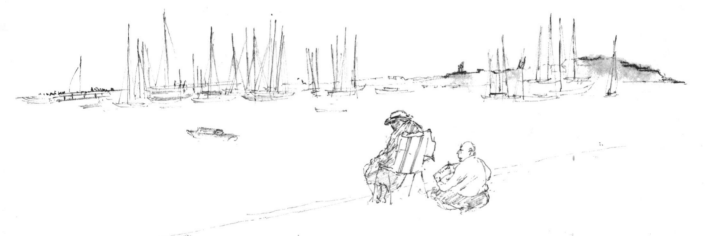

reproached with making fun of human frailties. This saddened him, and he wrote:

"This play of mine with brush and ink
Is neither calligraphy nor drawing.
Yet in the view of common-minded people
It becomes mere calligraphy and drawing."

In the minds of "common-minded people" – those who are blind – that which the draftsman's hand precipitates is an attempt to make an image of reality. To him who knows and sees it is a witness to reality. Its forms are reflections in the human eye from the Formless Whole.

Sengai also wrote:

"Every stroke of my brush
Is the overflow
Of my inmost heart."

And yet, I know artists whose medium is Life itself,
and who express the inexpressible without brush, pencil,
chisel, or guitar. They neither paint nor dance. Their
medium is Being. Whatever their hand touches has
increased Life. They SEE and don't have to draw.
They are the artists of being alive.

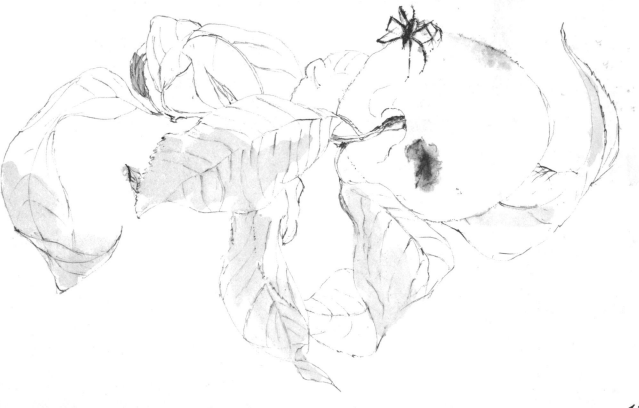

The twelfth-century Baso was one of these. When asked about his Zen discipline, he said: "When tired I sleep, when hungry I eat."

"Doesn't everybody do that?" he was asked.

"No," said Baso. "When others eat they do not eat with their whole being. They talk, they plan, they think, while eating and they dream and worry while asleep."

↓

This life is my windfall! That it happens to be a human life is the one chance in a trillion to be able to realize That Which Matters.

IN SEEING/DRAWING, THAT WHICH MATTERS CAN BE PERCEIVED THROUGH THE SENSES, NOT DENIED BUT MAXIMALLY AFFIRMED.

While SEEING/DRAWING I glimpse into Nature, I taste Nature, the Nature of Reality:

THE WAY OF SEEING IS A WAY OF KNOWING!

Key to the drawings

Africa 42, 44

Australia 43, 64, 84, 85, 122, 127

Austria 55

France 5, 17, 25, 31, 34/35, 45, 48, 89, 124

Greece 16, 123

Holland 38, 39, 52/53, 58, 71, 72, 73, 75, 91, 106/107, 109, 114

Hong Kong, Macao 4, 10, 11

India 46/47, 51, 54, 56/57

Italy 12, 22, 23, 36, 40, 41, 48, 50, 62, 66/67, 81, 82/83, 131

Japan 15, 43, 45, 49, 111, 113

United States 6, 7, 19, 20, 26/27, 29, 33, 59, 60, 61, 69, 70, 74,
76, 77, 78, 79, 80, 90, 92, 98, 112, 116, 120, 121, 125, 126, 128, 129

Portraits 93 Mr. Dennis Allen, U.S.A.; 94 Father Kaarsgaren, Vatican;
95 Mons. Spallanzani, Vatican; 97 Albert Schweitzer, Lambaréné;
96 Professor Linus Pauling, U.S.A.; 98 Pablo Neruda, U.S.A.;
99 Pope John XXIII; 100/101/102/103 Claske Franck; 104
Cardinal Ottaviani, Vatican; 119 Zen Master Nanrei Kobori, Kyoto.

A NOTE ON THE DESIGN AND
PRODUCTION OF THIS BOOK

The book was printed and bound by The Murray
Printing Company, Forge Village, Massachusetts.

The book was designed by Clint Anglin and Carole Lowenstein.